Doug Box's

FLASH PHOTOGRAPHY

ON- AND OFF-CAMERA TECHNIQUES
FOR DIGITAL PHOTOGRAPHERS

Amherst Media, Inc. □ Buffalo, NY

All rights reserved.
Published by:
Amherst Media®
P.O. Box 586
Buffalo, N.Y. 14226
Fax: 716-874-4508
www.AmherstMedia.com

Publisher: Craig Alesse
Senior Editor/Production Manager: Michelle Perkins
Assistant Editor: Barbara A. Lynch-Johnt
Editorial assistance by Chris Gallant, Sally Jarzab, and John S. Loder.

ISBN-13: 978-1-60895-258-8
Library of Congress Control Number: 2010904518.
Printed in Korea.
10 9 8 7 6 5 4 3 2 1

Check out Amherst Media's other blogs at: http://portrait-photographer.blogspot.com/
http://weddingphotographer-amherstmedia.blogspot.com/

CONTENTS

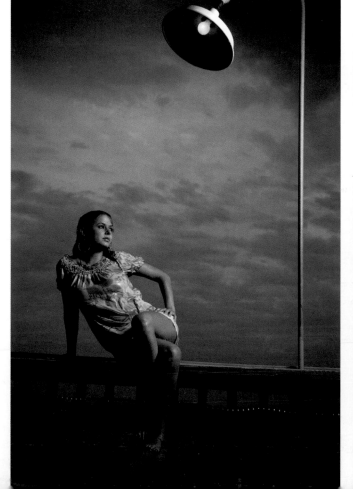

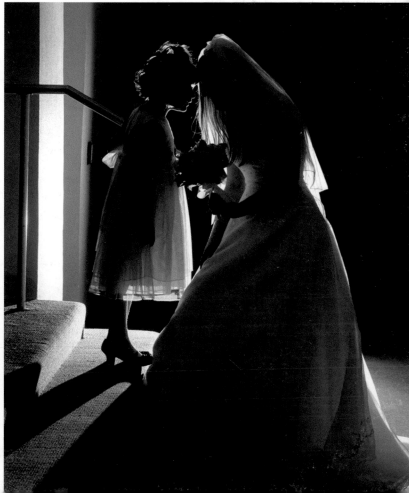

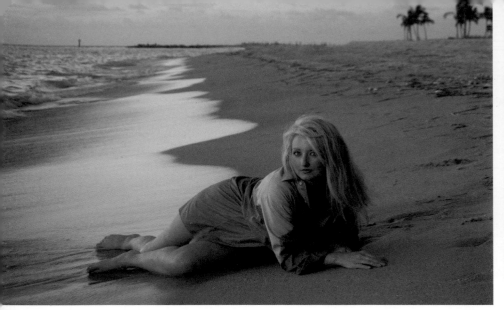
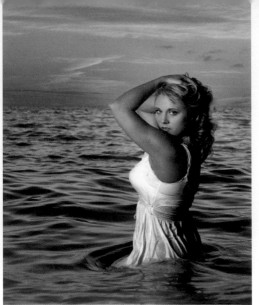

ABOUT THE AUTHOR

Photo by LaVelda Box.

Doug has been a professional portrait and wedding photographer since 1974, when he started his first photography business, which he ran out of his Houston, TX home. In 1976, he opened his second studio, in Brenham, TX, and later opened a third in Caldwell, TX. In the Brenham studio, he did almost every kind of photography, including in-home sessions, weddings, little league, commercial, pet photography, close-up photography, children's photography, outdoor and natural light photography, horse and rodeo photography, studio photography, and even photography at a funeral. In learning to do all manner of photography, he found that in each of these situations, there is a right and wrong way as well as an easy way and a hard way to use flash.

In 1977, along with a couple of friends, he started the Brenham Camera Club and started teaching hobbyist photographers. He conducted photo seminars for community education students, scrapbookers, and country club members, and was on a local TV station as the resident photography expert. In 1986, he began speaking to professional photographers around the country. He has spoken at conventions and seminars in forty-seven U.S. states and has also lectured in Canada, Mexico, Scotland, Wales, England, China, and Ireland. He was chosen to teach at the International Wedding Institute for four years and has taught at eighteen different Professional Photographers of America (PPA) Affiliate weeklong schools. He is only the fourth person in the history of PPA to earn over a thousand PPA Merits. Plus, he is a member of the prestigious Camera Craftsmen of America group.

Doug's articles and images have appeared in most professional photographic publications, and his images have twice been featured in *Redbook* magazine. He is the author of *The Power of Business* marketing systems and has written several books, including *Professional Secrets for Photographing Children, Professional Secrets of Wedding Photography, Professional Techniques for Natural Light Photography,* and *Doug Box's Guide to Posing for Portrait Photographers,* all from Amherst Media.

Doug is the owner of Texas Photographic Workshops, an internationally recognized educational facility where, along with his wife LaVelda, he hosts photographers from around the country, teaching all levels of photography. He is the owner of ProPhotogs.com, an educational photography forum.

For more information on Doug, go to www.dougbox.com. From there, you can sign up for his free e-newsletter and browse through lots of free information. You can also e-mail Doug at dougbox@aol.com.

INTRODUCTION

This book was written with photographers of every skill level in mind. Whether you are a seasoned pro or new to photography, you will learn strategies for using flash that will improve your photography.

For a lot of photographers, using flash is a bigger mystery than shooting in available light. I will do my best to demystify flash for you in many situations. In this book, I won't just show you what I do, but I will show you how you can easily use the same techniques in your own work. Most people tell me they don't like flash photography. I don't believe that is true: I think they don't like *bad* flash photography.

It is hard to believe how far flash photography has come. According to the book *Flashlight Portraiture* by John A. Tennant (Tennant and Ward, 1912), the first flash photograph was made while igniting magnesium ribbon. Ribbon gave way to magnesium or aluminum powder. Years later came flashbulbs, then flashtubes. Today, the flashtube is connected to a mini computer. With through-the-lens (TTL) flash metering, high-speed flash sync, front and rear curtain sync, and more, we have an incredibly sophisticated system of making flash photographs. Now, we need to learn how to use it properly.

My goal in this book is to give you the tools and the recipes to improve your photography, but more importantly, I want to show you that, with a little practice, you can easily make great flash photography. This is not like the manual that comes with your camera. This will actually make sense, with step-by-step instructions and before-and-after images to guide you through each process.

ABOUT THIS BOOK

There is a lot of information about flash out there. You may have encountered situations in which you've had trouble getting a successful shot—or perhaps you are a new shooter who has heard some stories about the challenges you may come up against when shooting with flash. Well, I've compiled a list of some of the important topics that I'll cover in this book.

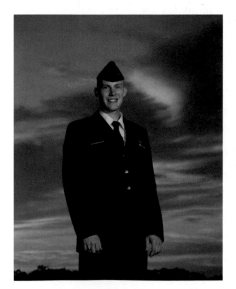

The combination of a beautiful sky, an off-camera flash, and an on-camera flash as fill yielded a well-lit image of a handsome man. The exposure was f/8 at $\frac{1}{80}$ and ISO 100.

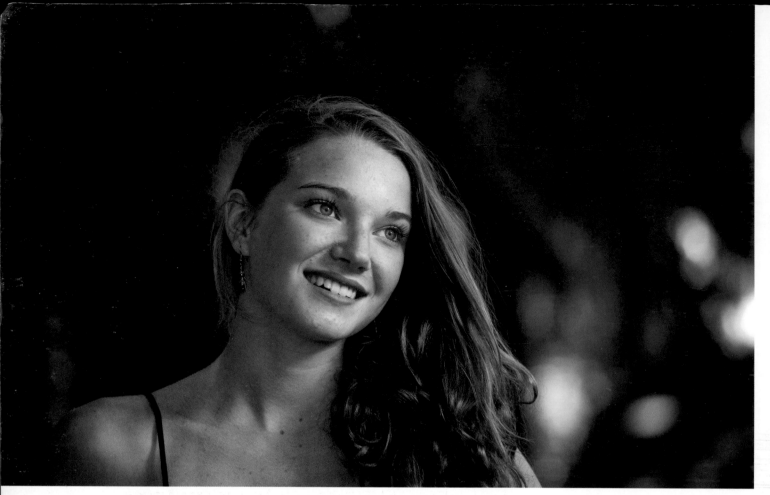

- Hate that on-camera flash look? I do. It just screams amateur. The on-camera flash creates a very flat light. It also tends to overpower the scene and make the background darker, making the flat light look even worse. I will show you how to use your on-camera flash so it makes your photographs look better, not worse. There is a right and wrong way to use your flash. Read on to find out how.

- Tired of taking too much equipment on location? When I used to do in-home sessions, I would have to transport two or three power lights, stands, extension cords, umbrellas or softboxes, and other items on location. It took forty-five minutes to set up and test the lights and twenty minutes to tear the setup down. It was a lot of work. Now I walk in with one off-camera flash on a stand with my 28-inch "Doug Box" Location Lighting System (more on this later), my tripod-mounted camera, and an on-camera flash. That's it. On-location photography is fun again, and the lighting looks great.

- Want an easy system for using multiple lights at weddings? There is nothing prettier than a well-lit wedding photograph. But most people think such shots are too hard to take and require too much equipment. I will show you that there is an easier way.

Flash allows you to create dramatic, flattering images of your subjects with minimal equipment, which makes shooting on location a whole lot easier.

PROPHOTOGS.COM

Doug is the owner of www .ProPhotogs.com, an educational photography forum. If you want more information on using off-camera flash, posing, studio lighting, business, and much, much more, check out www.ProPhotogs.com.

- Tired of buying the wrong equipment or unnecessary gear? I have a closet full of what I call "photo junk." You know what I'm talking about—all of the stuff the guy at the camera store said you had to have (but you never use). I will help you learn to see through the sales pitches in the stores and online and make solid, educated choices about your equipment. I will show you how to work with your flash and tack on a couple of inexpensive add-on flashes to make amazing photos.
- Frustrated with the white balance issue? I will show you how to do white balance the easy way and will teach you when it is okay to use the white balance presets on your camera.
- Do you want really distinctive lighting? You will have to admit, on-camera flash is boring. I will show you how to create really cool light-

ABOUT THE IMAGES

Very little postproduction manipulation was used for the images that appear in this book. In some cases, basic retouching was done (the softening of wrinkles and removal of blemishes). I shoot in RAW and use Camera Raw or Lightroom to convert my images to JPEG. In those programs, I use some image-enhancing presets that enhance the blacks and saturation. I also add a vignette to most of my medium- to low-key images.

In selecting images for this book, my goal was to prove that you can save a lot of time in postproduction by getting the image right in the camera.

I used the "Doug Box" modifier to produce soft, flattering light in this story-telling environmental image.

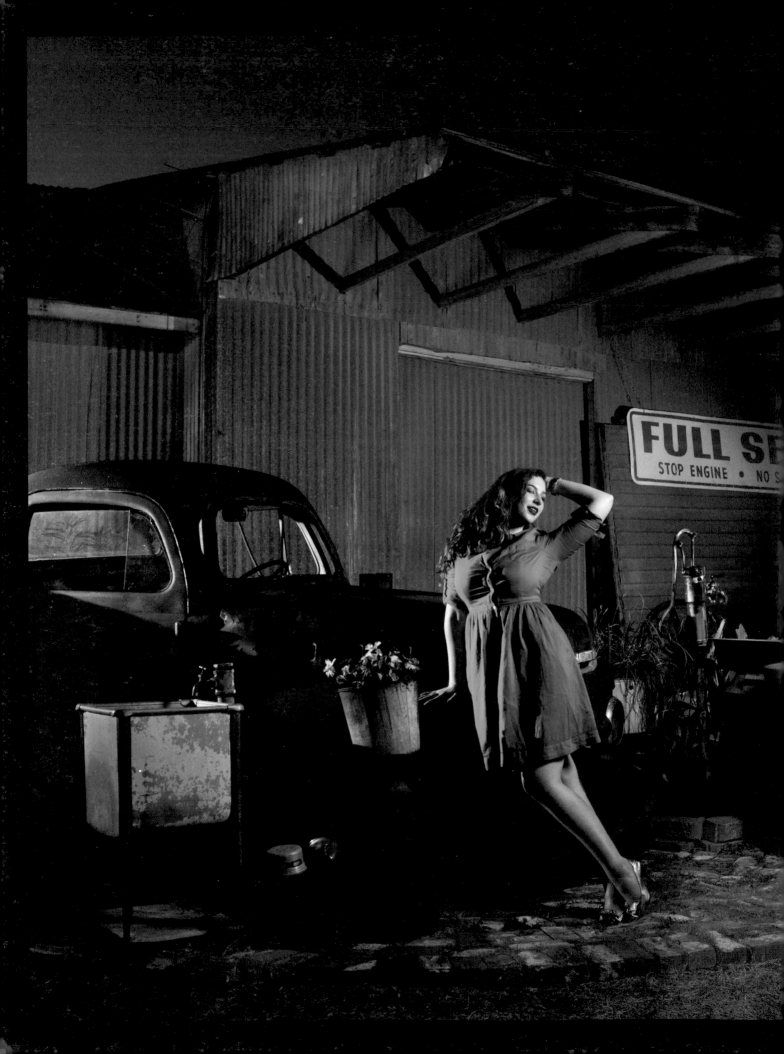

Left—Here is a natural light image. Note that the lighting is flat and the skin tones are gray. **Right**—What a difference adding flash makes. Using flash made the colors pop, removed the gray cast in the skin tones, and made for a much livelier, more professional image.

step-by-step instructions, cheat sheets, and recipes—and even provide before and after photographs—so you can put your newly acquired lighting skills to work *now*.

- I will show you an easy way to add beautiful, realistic, directional light to your outdoor portraits that will also clean up that gray skin tone that seems to show up in a lot of digital outdoor portraiture.
- Want a great kicker light for the studio or outdoors? There is nothing that adds depth, roundness, and professionalism to your images better than flash used as a kicker light.
- Do you want to ensure exciting lighting without spending hours working in Photoshop? This is one of my favorite things about using off-camera flash. The images look great right out of the camera. This saves me hundreds of hours behind the computer.

In this book, you will learn how one small softbox and a couple of battery-powered strobes can solve all of these problems and more. Let's get started.

EQUIPMENT NOTE

The majority of the information in this book will serve to help you better understand and use your flash unit—no matter the make or model. Some information, however, is specific to Canon EOS products, as that is the system I prefer to work with.

Facing page—Flash allowed for the creation of dramatic lighting with beautiful falloff in this vintage-inspired image.

1. LIGHTING BASICS

Flash is the most popular lighting source for many portrait photographers. These lights are powerful and work just as well outdoors and on location as they do in the studio. They are available at a wide variety of price points and configurations, and the units can be modified to produce light that is right for every application.

There is a lot to learn about how to use flash, but before we delve into the specifics about using your on and off-camera flash units, you'll need to understand some lighting basics.

FLASH

A flash is an artificial light source that emits a brief but very bright burst of illumination. It is one of the top lighting choices of portrait photographers, as it does not produce heat like incandescent light sources do. These units are made by Nikon, Canon, and other major camera manufacturers and third-party manufacturers, and they are available in a wide variety of price points. The power output that each unit is capable of will vary depending on the specifications of each flash. In general, larger, more powerful units are a better bet. Buy the biggest and best flash that your budget allows to get the most bang for your buck.

Modeling Lights. Most studio flash units are equipped with modeling lights—fairly weak, usually incandescent bulbs mounted inside an electronic flash head and located next to the flashtube. Modeling lights produce a continuous light that makes it possible to preview the lighting effect that will be produced by the flash. The majority of battery-powered flash units are not equipped with a modeling light. There are some battery-powered flash units on the market that have them. I own the Lumedyne and the Profoto Acute B 600. Both are good units. The modeling light on the Profoto unit is much brighter than the one on the Lumedyne. The Profoto is 600w/s. The Lumedyne can be modified to increase power up to 2400 w/s. The modeling light can be helpful, but be aware that it will run your battery down quickly.

A flash is an artificial light source that emits a brief but very bright burst of illumination.

HARD OR SOFT LIGHT?

All light, no matter the source, can be classified as hard or soft. Hard light produces bright highlights and deep, dark shadows with a hard edge. With hard lighting, light abruptly transitions to shadow. With soft light, there is a more gradual transition to shadow. Soft light makes subjects appear more dimensional and is more forgiving. It is the preferred quality of light for many portrait subjects. Hard lighting is well suited to some subjects and some applications (e.g., Hollywood lighting—the portrait style used by glamour photographers in the 1940s and 1950s).

The size of the light source relative to the distance from the subject determines the hardness or softness of a given light source. Larger sources placed closer to the subject produce softer light than smaller sources positioned farther away. For instance, we all agree that the sun is a large light source. However, it is quite far from the subject and, therefore, on a clear, sunny day, the sun produces hard, sometimes unflattering light.

You can change the quality of a light source by using a light modifier. There are an incredible variety of these on the market, and many people make their own from common materials. Among the modifiers that were

> *The size of the light source relative to the distance from the subject determines the hardness or softness of a given light source.*

Left—This image was made using a softbox with the front panel (or "face") in place. **Right**—This shot was lit with the same softbox with the front panel removed. Note the harder edge of the shadow and how the light is less spread out. This is especially apparent in the shadow on the neck.

used to create the images in this book are softboxes, scrims, and umbrellas. You can also change the hardness or softness of the light by moving your light source closer to or farther from your subject. We will take a closer look at this topic in chapter 3.

LIGHT FUNCTIONS

A flash can serve many functions in a portrait or other photograph, depending on its position, power output, and distance from the subject.

Main Light. The main light illuminates the subject. It is almost always the brightest light striking the subject. This light produces directional light that forms the shadow pattern on the face.

Fill Light. This fill light is a secondary light and should not overpower the main light. The purpose of the fill light is to add light to the shadow areas, making them less dense to ensure that the camera can capture detail in the shadows.

Kicker or Hair Light. A kicker light or hair light is usually a small light placed above and behind the subject typically opposite the main light. It adds detail to the hair and separates the subject from the background. It makes your photographs look more professional and gives dimension to the subject.

Background Light. The background light is used to create tonal separation between the subject and background. My favorite background light is a grid spot (a light fitted with a grid modifier [see page 15]), which allows me to throw a controlled beam of light behind the subject.

FALLOFF

Another thing about flash is it has falloff. The formula is called the inverse square law. It states: The intensity of illumination is proportional to the inverse square of the distance from the light source. 2x the distance is $\frac{1}{2}$ as bright, and $\frac{1}{2}$ the distance is 4x brighter (2 stops). What you need to remember is, flash is like me running: I start off strong, but quickly run out of steam the farther I get from the starting block.

FLASH HAS A LIMITED RANGE

One thing you need to know about flash is that it has a limited range. The intensity of the flash when it reaches a subject depends on the flash's power and on how far the light has to travel. The farther your subject is from the flash, the less light will reach it. I find it funny that, when watching a sporting event, amateur photographers use their flash to photograph the

EDGE ACUTENESS
When you are outside in the bright sun, the edge of your shadow is hard. This is called "edge acuteness." If you watch the edge of your shadow when a cloud passes between you and the sun, you will see that the edge of the shadow spreads out. That is the same thing that happens when you place a modifier in front of a flash. It softens the light or spreads out the edge acuteness. You can still see your shadow, but it is hard to see where the edge of your shadow is.

players on the field, who are about 600 feet away. Flash is good for 30 to 50 feet, so all they probably did was light the back of the heads of the people in front of them, hurting the photograph instead of helping it.

CATCHLIGHTS

A catchlight is not a light unit. It is a small, bright reflection of the main light in the eyes of the subject. I try to ensure they appear at about the 10 o'clock or 2 o'clock position. If the catchlight has not been retouched, you can tell what kind of light modifier was used to create the image.

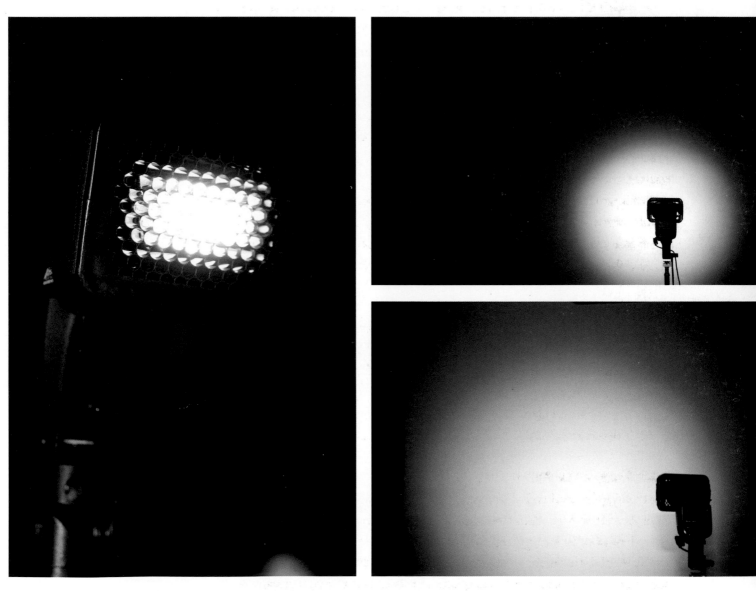

Left—A grid can be placed on your flash to narrow the beam of light that is produced, providing the photographer with increased control over their lighting. David Honl manufactures one called the Speed Grid, which is intended for use with battery-powered flashes. It is available at www.honlphoto.com. **Top right**—This photo shows the spread of the light achieved with the gridspot (a flash unit fitted with a grid) positioned about 3 feet away from the wall. **Bottom right**—This image shows the lighting effect that was achieved with the flash positioned about 6 feet away.

2. ON-CAMERA FLASH

Many cameras have a built-in flash, which can be handy on occasion, but if you want to make anything more than a snapshot, you should acquire an accessory flash, which can be used on or off-camera.

THE PROBLEM WITH ON-CAMERA FLASH

A small light source mounted close to the lens produces a very unnatural and unflattering form of light. To create lighting that best flatters your subjects and makes your images more salable, you've got to get the flash off of the camera.

That said, there are instances when you can use on-camera flash to produce decent images. Let's take a look at some of the variables that can be introduced to increase the effectiveness of this light source.

CREATING BETTER ON-CAMERA FLASH IMAGES

The light from an on-camera flash is hard, flat, and contrasty. Also, when the flash is pointed at your subject, the light on the subject is usually brighter than the background. There are ways around these problems. Let's take a look at a few of our options.

Bounce Flash. When you bounce the light from your flash off of a surface like an adjacent wall, the surface itself becomes the light source. This means that the light that strikes your subject comes from a source much larger than your flash and, therefore, the light is softer and more flattering for your subject. You can also angle your flash upward to bounce light off of the ceiling, but remember, an overhead light source can cast unflattering shadows, creating dark shadows under the subjects' eyes and making the top of the face brighter than the bottom of the face.

Keep in mind that some walls make for better light sources than others: a white wall, for instance, will not create an unpleasant and unflattering color cast in the image like a green or purple wall would. The distance between the flash and the wall and the reflectivity of the wall will also impact your final image results.

When you bounce the light from your flash off of a surface like an adjacent wall, the surface itself becomes the light source.

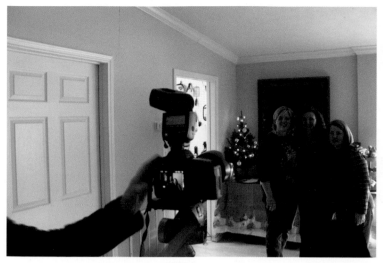

Left—This camera and flash are about 3 feet from the wall. Notice how the flash is pointed slightly forward and slightly upward. **Right**—Look at the beautiful, directional light on the faces of our subjects.

Left—When the flash is pointed directly at the subjects, the lighting is harsh and unflattering. **Right**—Here again, the lighting was improved by bouncing the flash off of a wall. Note that the image has much more of a studio lighting quality.

Light Modifiers. Light modifiers are tools used to make the light softer and more spread out or harder and more controlled. Some are designed to help you control the direction of the light, and others are used to completely block light from hitting a certain area of the subject or scene. Modifiers can also be used to reduce some of the contrast in your image (note that using a longer shutter speed or a faster ISO can sometimes do the same thing).

There are a variety of modifiers that can be used to improve your on-camera flash images. Years ago, I used a Larson Soft Shoulder (it was a small umbrella that the flash was bounced out of, over your shoulder).

This image was shot with the flash aimed directly at the subject. The light is very flat. Also note at the same shutter speed and f-stop, the background is darker than it is in the other images on this page. This is caused by light falloff. The background is simply farther from the flash than the subject is.

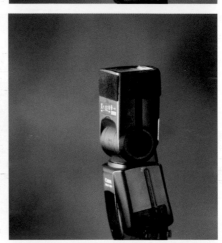

For this image, the flash was aimed at the ceiling. The bounced light scattered all around, but too much of it came from overhead, producing unflattering shadows. Another variation of this type of bounce flash is to tilt the flash head at an angle toward the subject. Watch your angle and distance. It is easy to point your flash past your subject.

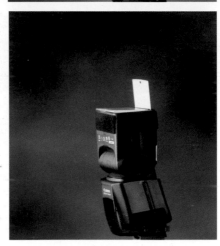

By aiming the flash at the ceiling and pulling up the little white card that is on most modern flashes, you can push a little light toward the subject's face, but you will still get a lot of top light. For years, I used a 3x5-inch index card, held to my flash head with a rubber band. While this works great to light up the background, the light is still flat.

I've also modified flash by using an index card, secured to the flash with a rubber band. This allowed me to point the flash at the ceiling and direct some light toward the subject, while letting the balance of the light hit the ceiling and scatter around the room. We'll see some images made with these and other modifiers later in this chapter.

This is a LumiQuest Pocket Bouncer. I have owned this one for years. It spreads the light from the flash, creating a softer light. It is more efficient than the white card or pointing the light toward the ceiling, because all of the light goes toward the subject instead of some going toward the ceiling and the back wall.

This is the LumiQuest 80/20. It pushes 20 percent of the light forward, letting 80 percent bounce around. It works better than the little white card.

There are accessories available for the LumiQuest 80/20 that allow you to further modify the light. A silver insert was used to create this portrait. The kit also includes a white and gold insert.

 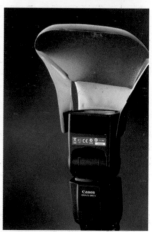

The last modifier is a styrofoam cup. It seems to do as good as the rest, although it does not look quite as professional. A lot of money has been spent on modifiers for on-camera flash, but no matter how you modify the light, it is still flat! After you see what off-camera flash can do, I hope you will give it a try.

 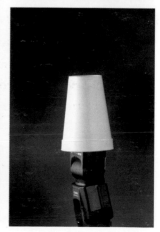

We've just looked at some portraits made with a variety of modifiers. Now, let's simply look at how we can change the quality of light by changing modifiers.

Left—This image shows the light produced by a bare flash head. Note the color of the wall above and behind the flash. As you can see, the wall is quite dark because the majority of the light goes forward. **Center**—Next is a Sto-Fen, a simple little cap that goes on the end of your flash and spreads the light around. See how the wall above and behind the flash looks. For more information, go to www.stofen.com. **Right**—This image shows the Sto-Fen tilted at a 45 degree angle.

Left—Here is the Lumiquest 80/20. You can see how it pushes some light forward while sending the rest upward. **Center**—This is the "Doug Box" modifier. You can see how soft the light is. It also falls off nicely around the edges. **Right**—Here is the "Doug Box" modifier with the face of the softbox removed and a Sto-Fen over the flash. I use this setup when I need a little more light and want softness but still want to keep the light from scattering all over the place.

THE PROBLEM WITH THE PORTRAIT IMAGE FORMAT

When you are working with on-camera flash, using your camera in the vertical position to photograph your subjects will produce big, ugly shadows. Look at the three images on the facing page and you will see how changing the camera position and using bounced flash will produce much better results.

Fill Flash. In cases when the background is brighter than the subject or when high-contrast lighting produces deep, unflattering shadows on the subject, we may need to add light to "fill in" the shadows. Most

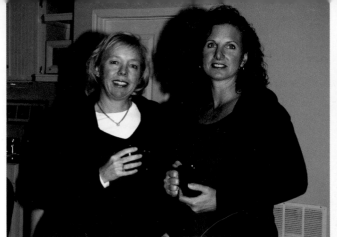
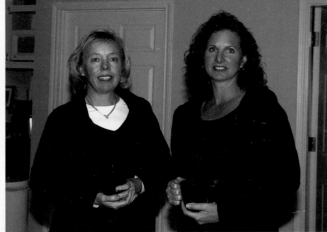

Top left—This image was made with the camera in the vertical position and was later cropped to the horizontal format. These ugly shadows are the result of using an off-camera flash and shooting with the camera held vertically. Top right—By turning the camera to the horizontal position, I was able to get rid of the deep shadows behind the subjects. Bottom—The lighting in this final image was enhanced by bouncing the flash off of a nearby wall. The softer lighting effect is more flattering to the subjects.

CANON FLASH EXPOSURE COMPENSATION

With the Canon 580 EX and EX II, with the flash in the E-TTL mode, push the small button in the middle of the dial and the exposure compensation amount will blink. With no compensation, the number 0 will blink. Turn the dial counterclockwise to decrease the amount of light the flash produces.

point-and-shoot cameras include a fill flash mode that forces the flash to fire, even in bright light.

Depending on the distance to the subject of the image, using the full power of the flash may greatly overexpose the person, especially at close range. Certain cameras allow the level of flash to be manually adjusted (e.g., $\frac{1}{2}$, $\frac{1}{4}$, or $\frac{1}{8}$ power) so that both the foreground and background are correctly exposed.

While this is not my favorite use of flash, in some cases, it is the only thing that works.

The lovely young lady in the images on the following page was having trouble holding still. I had her dad sit down and play with her and I backed up. I used the 200mm setting on my zoom lens to give me separation from the subject and throw the background out of focus. She was moving around a lot, and I knew trying to add off-camera flash would not have worked in this situation.

When using fill flash, you will need to use flash exposure compensation. This feature allows you to set the flash output to ±3 stops in $\frac{1}{3}$ stop

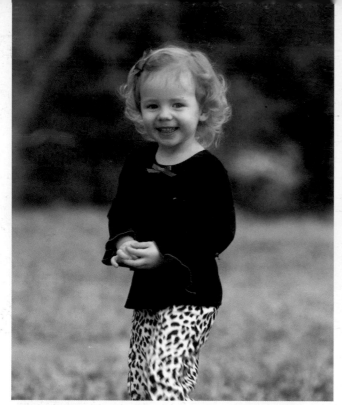 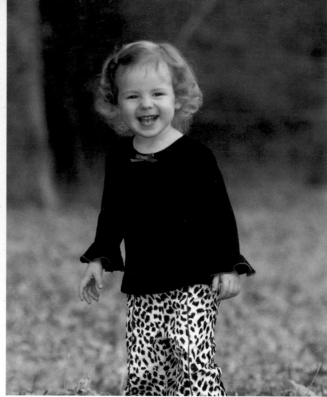

Top left—You can see the light direction coming from camera right. Note that the available light is not illuminating the mask of the face (the eyes, cheeks, nose, and mouth) and there are dark shadows under the subject's eyes. Exposure: $\frac{1}{60}$ at f/5.6 and ISO 160, no flash. **Top right**—Here I have added on-camera flash only. I used the TTL setting on the flash, which I set to −2. This created a fill light effect that did not overpower the ambient light. Exposure: $\frac{1}{60}$ at f/5.6 and ISO 160. **Bottom right**—This is a close-up view of an image made with on-camera flash. There is a small catchlight in the center of the eye. This is a telltale sign that on-camera flash was used.

increments. When I use the on-camera flash as a fill light, in E-TTL mode, my starting point is −2. If I want less fill, I set the flash at −3. If I determine that I want more fill, I use the −1 setting. See your flash's user manual to determine how this adjustment is made on your flash unit.

USING ON-CAMERA FLASH AS FILL WITH WINDOW LIGHT

Window light can be a beautiful light source. When you pose your subject near the window, what you see is what you get. By analyzing the highlights and shadows on your subject's face, you can determine whether the shadows are light and open, showing detail and creating a sense of dimension, or are too dark and require fill light.

With window light, there are three basic ways to lower the contrast (fill in the shadows): (1) use a reflector on the shadow side, (2) use on-camera flash set lower than the available light, or (3) move the subject farther from the window.

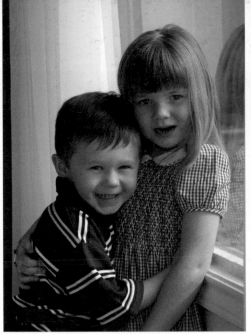

For this image, the young lady turned her face toward the light source. The light coming through the window perfectly illuminated the mask of her face. Exposure: $\frac{1}{60}$ at f/13 and ISO 160, no flash.

Here we have two images of siblings. The first image was made without flash. In the first image, the light on the girl's face isn't great. Only her cheek and nose are illuminated. To fill in the shadows, I set the on-camera flash to -2. While the light in the second image is not perfect, it is better than the image without the flash. Exposure for both images: $\frac{1}{60}$ at f/13 and ISO 160.

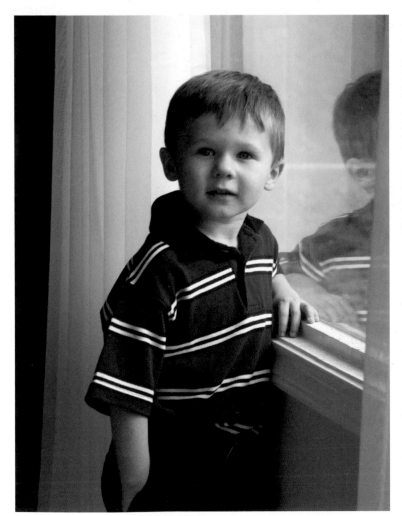

Left—This image was made using only window light. Exposure: $\frac{1}{60}$ at f/13 and ISO 160, no flash. **Right**—Here, a little bit of fill changed the look of the image. Exposure: $\frac{1}{60}$ at f/13 and ISO 160, TTL flash, set at -2.

Left—This image was made using only window light. Exposure: $^1/_{30}$ at f/4 and ISO 200, 200mm lens, no flash. **Right**—Here, the window light was supplemented with fill flash. Note that the subject seems to smile more when the flash is on. Exposure: $^1/_{30}$ at f/4 and ISO 200, 200mm lens, with flash. It seems the subject seems to smile more when the flash is on!

 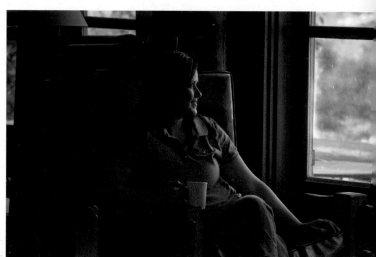

Left—This image was made using window-light only. Exposure: f/9 at $^1/_{10}$ second. **Right**—In this image, you can see the way the fill light opened up the shadows and cleaned up the green color. This image was shot using the camera's flash white balance preset. Exposure: f/9 at $^1/_{10}$ second.

What's So Great About the "Doug Box"?

I have been a pro for over thirty-five years, and I developed the "Doug Box" Location Lighting System—a softbox that can be used on an off-camera or shoe-mounted flash. It provides many important benefits:

○ soft light—The "Doug Box" is 28 inches, big enough to produce soft light, but not so big that it is cumbersome. It can be transported easily. I use it for weddings, outdoor shots, home sessions, and in the studio.

○ shape—The "Doug Box" modifier has an octagonal shape. This creates a much prettier catchlight than a square or rectangular box.

○ easy setup—The "Doug Box" modifier sets up in seconds.

○ well made—The ribs in my box are made of solid steel, not tubing that will break if it is bent. If the ribs become bent, they can simply be straightened. When I was testing different designs for my box, I went out on the roof of the studio and dropped the modifier five times. If it broke, we changed the design. (I changed the design nine times before I came up with my final product.)

○ efficient—The "Doug Box" was made for use with battery-powered flash. To make it as efficient as possible, I designed it with a super silver lining. (Without it, you would lose up to one stop of light.) There is no baffle on this box; with a modifier this size, a baffle would only reduce the amount of light, not soften it.) Due to the shape of the box, the modifier pushes most of the light forward but still gives a beautiful falloff, which is great for portraits.

○ versatile—When designing the "Doug Box" modifier, I wanted to be sure it would work with as many flash brands as possible, without a need for consumers to buy adaptors. The box comes with everything you need to use it with all shoe-mount flash units, plus many other models from other major manufacturers, including studio strobes, without the need for adaptor rings.

○ works with flashes using the built-in infrared slave system—You can turn the body of the flash and keep the head pointing toward the face of the softbox.

○ Included with your purchase is a multi-page booklet on how to assemble the box and a DVD on how to use it. Also, you can contact me with questions.

For more information go to www.dougbox.com/shop/.

Left—The "Doug Box" is a lightweight softbox that is designed for use with off-camera or shoe-mounted flash. **Center and right**—The Doug Box can be used with flash units from a variety of manufacturers, without the need for an adaptor.

3. OFF-CAMERA FLASH

One of the best features of an accessory flash (often called a flash gun, speedlight, electronic flash, Speedlite [Canon] or Speedlight [Nikon]) is that it can be taken off of the camera. The images and captions below show why this is a clear benefit.

ESTABLISHING COMMUNICATION BETWEEN YOUR CAMERA AND FLASH

With on-camera flash, the flash sits on top of the camera and is connected to the camera via the hot shoe. This connection to the camera's computer allows for TTL, E-TTL, or i-TTL (depending on what each camera manufacturer calls their automatic version of through-the-lens flash metering system) and more.

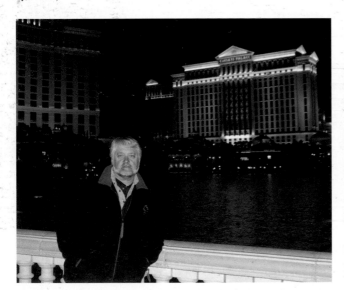 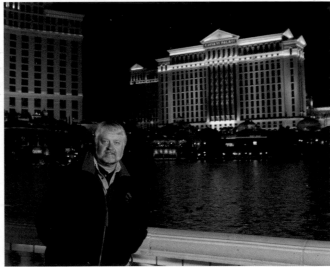

These self-portraits, made in Las Vegas, clearly show the difference between on-camera flash and off-camera flash. The image on the left was made with on-camera flash. Note how the light on my face made it look wider, fatter, and flat. Trust me, I don't like that, and neither will your subjects. Because the on-camera flash is indiscriminate, my jacket received too much light. The image on the right was made with off-camera flash. I positioned the light source at about a 45 degree angle to my face, both horizontally and vertically. In this position, the flash was brightest on my face, and the falloff (the decrease of intensity as the light spread outward from its brightest point) made my jacket and the length of my body darker. This is important, as the portrait viewer's eye is usually drawn by the brightest tones in the image.

While I was demonstrating the use of off-camera flash during a photo seminar, one of my students snapped a photo over my shoulder using on-camera flash and their in-camera meter. In the off-camera flash image (left), the exposure was f/6.3 at $\frac{1}{200}$. The exposure in the image taken by the student was f/4 at $\frac{1}{100}$. The exposure in my image was $2\frac{1}{3}$ stops darker. As you can see, this produced shadows that slimmed the body and added interest in the image.

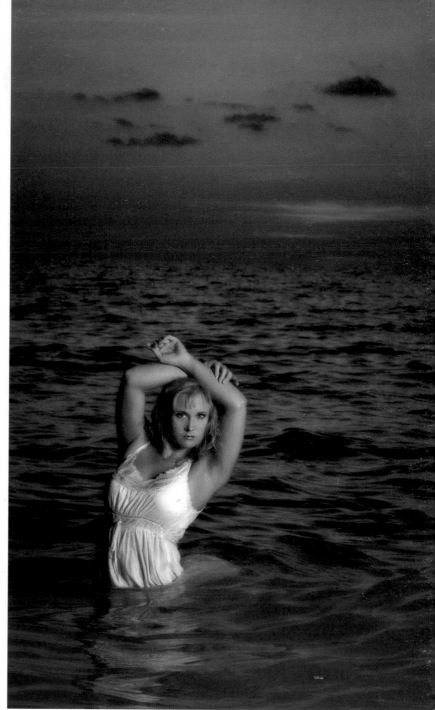

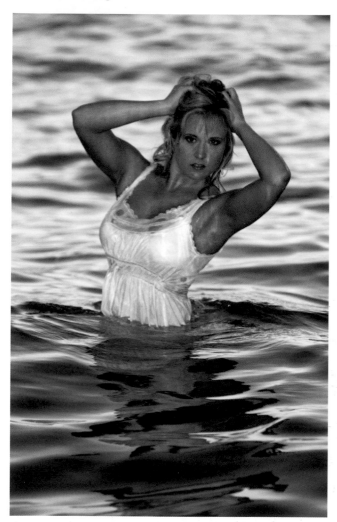

When we take the flash off of the camera, we lose this connection unless we use a short, specially designed cord or a "slave" (a system that allows communication transfer). With a communication system established, we can tell the flash units when to fire and how much light the shot requires.

Sync Cords. When I first started my business, I used sync cords. They were cheap and a good choice for me at the time. I did not have much money, and I could fire multiple flashes both in the studio and outdoors.

However, they were fragile and had to be replaced frequently. They were always in the way and easily tripped over. And today they can be dangerous to your camera. The trigger voltage of some flashes, especially older ones, can damage your digital camera.

Optical Slaves. An optical slave "sees" the light from the master flash, then triggers the slave flash. This system works very well at slower shutter speeds—$\frac{1}{60}$ or $\frac{1}{125}$ and lower. In fact, in my first studio we used a combination of a sync cord to the main light and optical slaves on all the other flashes. Many studio flash units come equipped with a built-in optical slave. An "add-on" optical slave will run $20–$100. There are several drawbacks for these relatively inexpensive units. First, they are nondiscriminatory. In other words, anyone's flash can trigger your flash. I tried using an optical slave at a wedding when my radio slave went down. Whenever I tried to fire my flash to set off the second light, someone else's flash would trigger it first. That flash was even triggered when I wasn't shooting. Also, these units don't work outside as well as they do inside. But today, the biggest problem using an optical flash with Canon's E-TTL or Nikon's I-TTL is the pre-flash. The slave detects the pre-flash and fires before the camera's shutter is open and the real flash is fired. A company called Morris makes optical slaves that work with some TTL units.

Infrared Slaves. Another type of slave on the market allows the flash and camera to communicate via infrared light. The advantage of infrared triggers is that they are wireless. The big disadvantage is that they are mostly line of sight. In other words, if anything is blocking the transmitter or receiver, the system won't work. Another disadvantage is that, since they are triggered when they "see" another flash, another photographer's camera/flash system could cause your flash to fire.

Radio Slaves. A radio slave is a system comprised of a transmitter, which is attached to the camera via the hot shoe or PC connection and a receiver, which is connected to the flash. The two units communicate only with one another. This keeps other people's flashes from triggering your flash. PocketWizard, Quantum Instruments, and Radio Popper all make radio triggers that can be used with most cameras. There are many advantages to using radio slaves over sync cords and optical slaves. First, they cannot be fired by another flash. They have multiple channels, so they can be set to a channel different from other photographers. Another advantage is that their effective range is longer than any of the above units—typically in tens or hundreds of yards. One of the biggest advantages is that they do not require line of sight. The two brands I

A flash bracket is an essential part of the professional photographer's gear kit.

FLASH BRACKETS

A flash bracket is used to hold the flash off the camera. By raising the flash, you change the angle of the flash entering the eye, so that the light that hits the retina cannot come back out of the pupil, causing red-eye. For me, one of the most important features of a flash bracket is it should keep the flash directly above the axis of the lens. This keeps the shadow from the flash directly behind the subject instead of beside the subject, thus minimizing the size of the shadow. The flash bracket I use is made by Custom Brackets.

MODIFYING OFF-CAMERA FLASH

A softbox is a box-shaped light modifier that is used to diffuse and soften light. It directs light forward and keeps it from bouncing around the room. A scrim is a panel made of translucent or thin white material that spreads the light out and diffuses it, making it less contrasty. An advantage of using a scrim is that you can move the flash to any position behind the scrim. These come in a wide range of sizes—from 1 foot to more than 10 feet (Hollywood photographers have access to much larger scrims—they can be tens to hundreds of feet long). I use the Westcott Scrim Jim. An umbrella is another commonly used modifier. It is a concave-shaped modifier that is usually lined with white, gold, or silver fabric that bounces the light, creating a larger spread of light.

will talk about are PocketWizard Plus II and Radio Popper Jr. I also own Quantum 4i transmitter and receivers. I don't use them anymore, not because they don't work, but when Sekonic introduced meters that could be equipped with a PocketWizard transmitter inside the meter, I switched to PocketWizard and Sekonic meters. This allows me to trigger the flash with the meter. This saves me lot of time and is very convenient. It also allows me to look and act more professional. As far as I know, this is the only system that works this way. I really enjoy this feature.

Smart Wireless Triggers. I also use two different brands of smart wireless triggers, the Mini and Flex from PocketWizard and a Radio Popper. On the following pages, I will discuss these systems, including the advantages and disadvantages of each. I feel that it is important to use the tool that is best suited for each particular job.

WHAT SHOULD I BUY?

I am often asked, "Which flash should I get?" I almost always recommend the dedicated flash that goes with your camera. In many cases, there is more than one option available, and, when there is, I tip my hat to the most high-end model available. There is a relatively small cost difference between the best flash unit and lesser models. It is best to buy the best model you can up front because as a photographer's passion for art and their knowledge grow, so does their desire for more power and features.

You'll also need a slave system to trigger your flash.

Here is a concise list of the equipment I use:

- Bogen/Manfrotto 458-B tripod with a G-1376M Gitzo ball head (This is the coolest tripod I have ever owned. To see why, go to my web site at www.dougbox.com/tripod.)
- 13-foot light stand
- Two or more Canon 580 EX II flash units
- A couple of Morris slave unit flashes
- A pack of gels
- A bracket to get the flash up off the camera
- A Canon flash extension cord
- A set of radio triggers

FULLY AUTOMATIC WIRELESS FLASH

One of the most desirable and important flash features is TTL (through the lens) metering. Here is how it works: The camera fires a small pre-

The two flashes firing in the background were set off using the Canon's E-TTL system. This image was taken by my assistant, Daniella Weaver.

flash, which leaves the flash unit, strikes the subject, and is reflected back toward the camera. Some of this light passes through the lens and is measured. The camera then calculates the flash duration needed for proper exposure, and outputs the correct amount of flash to achieve a proper exposure.

In most of the TTL flash systems, the camera not only meters the flash output, it also takes into consideration the amount of ambient light in the scene.

When you are shopping for a flash unit, you might come across features called E-TTL II (Canon) or i-TTL (Nikon). Canon has introduced its E-TTL II, which incorporates the distance and other information from compatible EF lenses for a more accurate flash exposure. Nikon flashes use what is called i-TTL, a system that measures the light that passes through the lens via a matrix metering approach to create a more accurate flash exposure.

Using TTL metering can produce better results than using the auto flash setting. Here's why: If you were standing in a crowded area and taking a photo, the light from your flash would hit and bounce off of everything in the path of the light. Only the light reflecting off of the subjects the lens could "see" would enter the lens and affect the exposure calculation. On the other hand, when you use your flash in the auto mode, the sensor on the flash itself will read the light reflected from subjects within the view of the lens and out of view as well. To correct for this problem, you would have to move the camera closer to the subject or clear the clutter out.

AUTO SYSTEMS

If you are just starting out or are an advanced amateur, Canon or Nikon's auto system might work for you. Pros, on the other hand, require a system that can be set up quickly, works every time, and doesn't require a lot of guesswork.

Note that Quantum makes flashes that work with Canon and Nikon systems, and Metz produces units that can be used with Canon, Nikon, Pentax, and Olympus systems.

CANON'S WIRELESS SPEEDLITE SYSTEM

I only use Canon's wireless Speedlite system occasionally. When I do use it, I typically use it with one of the smart radio triggers. (When used alone, it must be used within the physical limitations of the system.) It requires two flash units or one flash and the ST-E2 transmitter.

The two units must be able to see each other. I can't place the second light behind the on-camera flash while using the on-camera flash as part of the exposure. I can't use the off-camera flash in a softbox with profile lighting, and I can't use it outdoors past 30 feet. I also cannot hide the flash behind anything.

As you will see, I use the E-TTL on the camera with the off-camera flash on manual with a radio slave all the time—and it works each time. I also use the Radio Poppers and PocketWizard Flex in certain situations. Sometimes they work just as you want them to. In other cases, the system's limitations are prohibitive. When you're working with a client, this is not a problem you want to face, as not being able to take a photo would not be very professional. Sure, you could change systems, go through all of the menus, turn off the master and slave, hook up the PocketWizards and start over—but who wants to do that?

Because there are so many different flash and camera models available, it's not possible to delve into a discussion of every unit. Instead, I will cover the basic concepts behind using the system. See the user's manual for your specific gear for more detailed information. *(Note:* There are some similarities in operation between the Canon and Nikon systems.)

When using the Speedlite system, keep the following basic points in mind:

- Make sure all of the flash units are set to the same channel.
- The on-camera flash is the master unit and the off-camera flash is the slave unit. When multiple off-camera flashes are used, each one is a slave unit.
- The master flash can be part of the exposure or it can just trigger the other flashes.
- Both Nikon and Canon systems have ratio systems, which allow you to shoot with one flash brighter than the others. I find these systems

The master flash can be part of the exposure or it can just trigger the other flashes.

confusing and inconsistent. Using them requires a lot of chimping and adjusting, so I don't use them. I will show you a simple method for using multiple flash units later in the book.

THE NIKON CREATIVE LIGHTING SYSTEM

Nikon's Creative Lighting System is set up and used in much the same way as the Canon system. It also has many of the same limitations. Both are line of sight systems and require a narrow angle of use. A manual system allows me to grab my meter, take a couple of readings, and start taking photos while other photographers are navigating the menus, taking test shots, finessing their menu selections—in other words, before they even start shooting. By the time they're ready to shoot, I am already halfway through the session.

THE POCKETWIZARD MINI AND POCKETWIZARD FLEX

When I first heard about the PocketWizard Mini and Flex systems I was so excited. I teach many photographers how to use off-camera flash, and I hear the same thing over and over: "Tell me how to do it in automatic!" So, when PocketWizard announced the new system, I thought it was an answer to my prayers. They would allow me to use my Canon flashes in automatic mode without dealing with the limitations of built-in systems, and my students would be happy too. Another benefit was that I could still work with my original PocketWizards.

Well, every dream comes to an end, and you wake up. Canon flashes emit some radio waves that interfere with the signals produced by the PocketWizards. Therefore, you have to use a specially designed black sock and an electronic filter to increase the range.

I own the Mini, but I don't use it much anymore. I use two Pocket Wizard Flex units instead. The Flex is a little bigger and has an antenna, so it can be used at a longer range. Another benefit is that it takes two AA batteries instead of the little flat CR2450 batteries. They are less expensive, available everywhere, and last longer.

The new PocketWizards take the TTL signals from the camera and flash and convert them to radio signals. This gives the units greater range than the Canon built-in system. To make changes to the settings, you will need to download the PocketWizard utility and hook your PocketWizard up to your computer. This isn't as convenient as flipping switches, but it will give you more flexibility and you can upgrade the firmware as changes are made to the system down the road.

The new PocketWizards take the TTL signals from the camera and flash and convert them to radio signals.

If you are ever on a shoot and find that the system isn't working correctly, you may need to reset the units. Turn them off, hold down the test button, and turn on the unit. Continue to hold the test button down until the unit blinks four times in a row.

Warning: Be sure that everything is powered off when you put the Flex on your camera and mount the flash on the Flex. Also, with the Flex system, you do not use the flashes in the master/slave mode. Just use the TTL mode.

I have a bad habit of forgetting to power these units off, so I am always running the batteries down. Therefore, I have gotten into the habit of putting in fresh batteries before every wedding and change them every week for portrait sessions.

As you will learn in these pages, there are several ways to use off-camera flash. Instead of covering each of the methods here, I'll explain how to use the Flex in two scenarios: (1) in scenes in which the background is brighter than the subject (e.g., in a sunset portrait), and (2) in scenes in which the ambient light provides fill light for the subject.

When the background is brighter than the subject, I use the evaluative metering setting (on Canon models; Nikon's version is called matrix metering). I set the exposure compensation to –1. This causes the background to appear one stop darker, and therefore richer in color. I then set the flash compensation to 0. This ensures that I will achieve a perfect exposure on the subject. At this point, you will have to look at the back of the camera to determine if the exposure on the subject is enough. If not, increase the flash compensation to +1, +2, or +3.

When I am shooting a session in which the ambient light serves as fill, I set the camera's exposure compensation amount to $-\frac{2}{3}$ stop, then set the flash compensation to –1 in TTL mode. The ambient light and the flash will combine to make a proper exposure, and the effect of the flash will be very subtle. (Remember that in all cases in which the camera is used in automatic mode, the camera will average the tones in the scene to 18% gray. If the scene you are photographing is not 18% gray, you will need to make some adjustments to your overall exposure to ensure that the darker and lighter tones are properly represented.)

The PocketWizard Flex offers many impressive options/features:

- When your flash is connected to your camera, using a radio slave will typically slow your sync speed a little. The Flex's HyperSync feature allows the wireless flash to sync at a higher speed than you would

achieve with your flash on the camera. For model-specific tips on how this is done, go to www.pocketwizard.com or www.robgalbraith.com.

- The Flex will work with your original PocketWizards. They all share channels. A Mini TTL or Flex can trigger a Plus II connected to a remote flash.
- With the Flex, you can fire your off-camera flash without a flash on your camera. This is not the case when using a Radio Poppers unit or the built-in system.
- Several studio flashes have PocketWizards built into the studio flash.
- The biggest selling point, for me, is that you can use a Sekonic meter's built-in Pocket Wizard transmitter to trigger the flash.

RADIOPOPPER PX

Wow! What a cool invention. The RadioPopper PX system allows you to use your flash's built-in automatic and high-speed functions without having to ensure that the units can "see" one another. To use the system, simply mount the RadioPopper transmitter to your master unit and attach a PX receiver to each flash. The PX transmitter will "listen" to the light signal being created by the master flash and will send this signal via radio wave to be read by the PX receivers. The receiver will then emit a light signal through the back of the receiver and send it to the infrared sensor on a slave flash. The slave flash will respond and fire, as it would if it could "see" the light from a master flash.

RadioPoppers can be operated in full E-TTL mode or manual mode, in all E-TTL channels, groups, or ratios. The system is compatible with their JrX system, too. (This is a great system that is similar to the Pocket Wizard.)

If you are considering purchasing this system, keep the following points in mind:

- RadioPoppers run on AAA batteries, which don't last as long as AAs. Also, because the system continues to send out small signals, even when it is not in use, the batteries should be replaced every time you use the system (or at least taken out between sessions).
- In order to use the system, you must have an on-camera flash as a master unit. If you want to fire an off-camera flash, you will need two RadioPoppers and two flashes, even if you are not going to use the on-camera flash as part of the exposure. Since I don't use the system's ratio feature, I see this as a slight disadvantage.

The RadioPopper PX system allows you to use your flash's built-in automatic and high-speed functions without having to ensure that the units can "see" one another.

WHY MANUAL FLASH MODE IS A GOOD CHOICE

Automatic flash is convenient. It can get you close to the right exposure and works fine about 70% of the time. Unfortunately, your automatic flash is designed to produce correct exposure for an average scene containing average tones.

Top—The open shade created an overall blue cast in this image. There is no real direction to the light and there is nothing blocking overhead light, which caused dark shadows under the subjects' eyes. The existing light provided great fill—I just needed a main light. **Bottom**—Here, off-camera flash cleaned up the color, added direction to the light, and replaced the top light with a softer, more flattering light. It appears as if the sun was setting at camera right and skimmed the ground, illuminating the children's faces.

For the best results, I like to use my off-camera flash in the manual mode and use a flash meter to determine the correct exposure. Without the meter, there is a whole lot of chimping going on. I will show you how to use both modes.

MULTIPLE FLASH

There are many occasions when you'll want to use more than one flash to get the best-possible lighting on your subject:

- In portraiture you can use a second flash to fill in shadows created by the main light.
- You can use a second or third flash as a background light to create separation and a feeling of depth in an image.
- A second or third flash can be used as a kicker light to add dimension in your photographs.
- In architectural interior photography, you can light specific areas of a room with additional flash units.
- In wedding photography, you can use an off-camera flash as a main light. In the large group photos, a second flash can be used as an accent light to add texture and dimension in your photos. At the reception, a second or third light can help light up the room. If you are photographing the cake, it will help you reveal the texture in the cake and will keep you from blowing out the detail (this commonly happens when using only the on-camera flash). Finally, using a second light to photograph the couples on the dance floor will help you make the scene look like a party, as you will be able to better see people dancing.
- For copy work, two flashes stop reflection and help light the entire piece evenly.

I'M ON A BUDGET. WHAT CAN I DO?

The dedicated flash for your camera will run you about $400. And if you want to do all the fun things that can be done with dedicated flash units, I know you will eventually get one (or several). But until you can afford a good one, you can use any flash, as long as you can sync it to a PocketWizard or other firing mechanism and can adjust the power. Non-adjustable flashes can work, but they are not as much fun. So, next time you are at a garage sale, pick up any flashes they have (a good choice is the workhorse Vivitar 285). You can never have enough.

You can use a second or third flash as a background light to create separation and a feeling of depth in an image.

Top left—The setup shot. **Top right**—Image shot without flash. The incident light reading was $^1/_{125}$ second at f/6.3 and ISO 400. Then I added the flash at $^2/_3$ stop over the ambient reading. I turned the flash up until the final reading was $^1/_{125}$ second at f/8 and ISO 400, then captured the image. **Right**—This shot was created with only a camera, light stand, umbrella bracket, translucent umbrella, Vivitar 285, Quantum radio slave transmitter, and receiver. Great images can be made on a small budget.

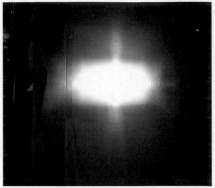

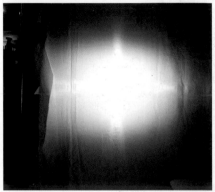

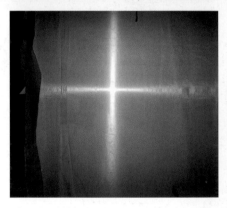

For this shot, I used flash bounced into an Omni Bounce, which I'd positioned on a window sill. (I didn't have a softbox handy.) Window light was illuminating the room, but the color and quality of the light wasn't good, since it filtered through trees and bounced off of a brown building before entering the room. By adding flash, I was able to add direction to the light and clean up the color. The exposure for this image was $^1/_{30}$ at f/4 and ISO 160.

By moving your flash closer to or farther from the scrim and using the zoom feature, you can change the size of the light source and the softness of the edge of the light.

A studio portrait like the one above could be made with a garage sale flash, a LumiQuest Pocket Bouncer, and a long PC cord. A meter would be helpful, but you could use the guess-and-chimp method if need be. However, the cost of a meter and the time savings you can reap by quickly achieving an accurate exposure are a small price to pay for good results.

When you are working with a tight budget, a scrim (I use an FJ West-cott Scrim Jim) or a light panel can be a great choice. Using a scrim, you can position the light closer to or farther from the panel, at any point across its length. If you are on a budget, you can build your own scrim out of ¾-inch PVC and some translucent nylon.

Another way to use off-camera flash on a budget is to use an umbrella instead of a softbox. However, it's not an optimal choice because light spills out of the back of an umbrella, and an umbrella can cause lens flare. Also, when you use them outdoors, they can catch the wind like a sail. Another issue is that, because the face of an umbrella is curved, the light that is produced is less directional.

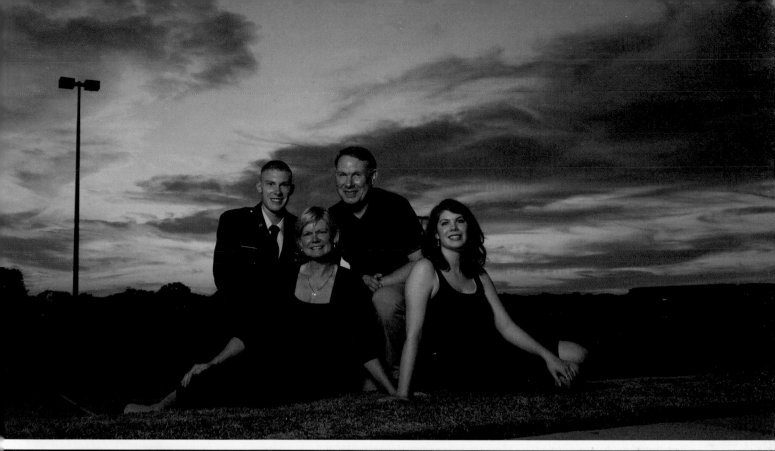

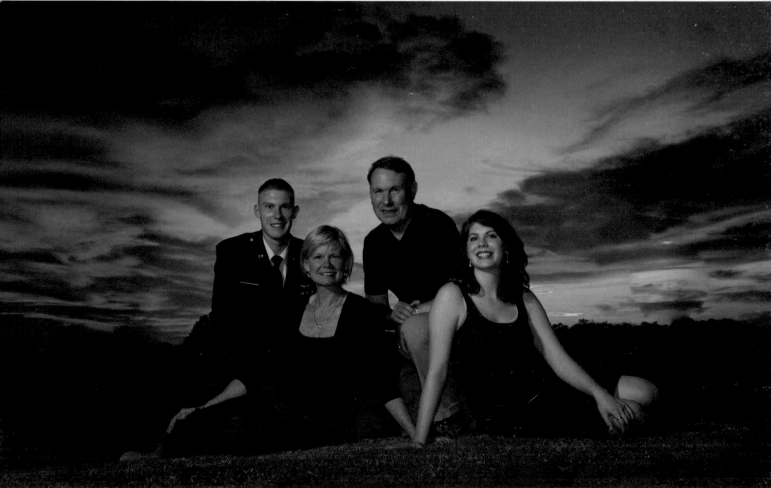

Top—This image was made with only on-camera flash. **Bottom**—To get this more dramatic image, I set up battery-operated flash as a main light and used on-camera flash for fill. I chose a low camera angle, did some creative cropping, then did a little Photoshop work to remove the lights from the shot. Adding fill light made a big difference.

I prefer softboxes to umbrellas. The flat face of a softbox makes the light more controllable. When placed in the proper position, and with the face of the softbox parallel to the subject, the light falls off beautifully. This means that the subject's face is the brightest part of the image, and the light transitions to shadow as it moves from the face toward the length of the body. Note that in the image on the previous page (made with an umbrella), the light is about the same on the subject's face and body.

BATTERY-POWERED FLASH

Battery-powered flash units allow you to create studio lighting anywhere, indoors or out. They are portable and versatile. However, they are not designed for heavy use. You can damage your flash if you fire too many high-powered bursts of light in a short period of time.

Also, as noted earlier, the majority of battery-powered flash units are not equipped with modeling lights. This can make visualizing the effects of your lighting difficult. Select units do have modeling lights, but using them tends to quickly drain your batteries.

STROBOSCOPIC FLASH

Stroboscopic flash is a repeating flash mode found on some flashguns. When used under certain conditions, it produces multiple exposures in a single frame.

FLASH AND ZOOM

The zoom function on your flash is an interesting tool. For the most part, this feature is used automatically as you change lenses or zoom your lens, and it makes your flash more efficient. However, you can also use it creatively to change the size of the flash output.

THE SYNC SPEED TEST

Another way to check your maximum flash sync speed is to put your flash on your hot shoe and find a white or light-colored subject. Next, set your camera in manual or shutter priority mode. Starting at $1/60$ second, photograph the wall. Next, increase your shutter speed and take another photo. Repeat this step, and eventually you will see a strip of black on the bottom/top of the frame. (This occurs when the rear shutter has begun to cover the film/sensor while the flash is firing.) Your camera will sync at any shutter speed slower than the one that yielded the black area, but not beyond this point.

Most cameras sync around $1/200$ or $1/250$. Some low-end cameras have a $1/90$ top sync speed, and a few of the top-end pro models can sync at $1/300$ or $1/500$.

These two images were made in the studio. The image on the left was shot at $1/250$. The dark area at the bottom of the image was the result of using a too-fast shutter speed. The second image was made at $1/125$, within the sync speed limitations.

Wow! Look at the difference between these two images. The first image was made at $\frac{1}{30}$ at f/4 and ISO 200. The second was made at .06 second at f/4 and ISO 200. As you can see, selecting a slower shutter speed allowed me to capture the detail behind the subject. To create this shot, I took a meter reading of the background using my in-camera meter then brought in the flash at the same f-stop reading.

ABOUT SYNC SPEED

The Camera's Shutter. The camera shutter consists of two curtains that travel across the front of the image sensor. In shutter speeds of about $\frac{1}{200}$ second or slower, the front curtain opens, uncovering the sensor/film. This starts the exposure. When the length of time described by the shutter speed setting has elapsed, the rear shutter follows the front one, covering the sensor and ending the exposure.

Maximum Sync Speed. To achieve a correct exposure when using flash, we must select a shutter speed that allows the flash of light to evenly expose the sensor while the sensor is fully exposed. If the shutter speed is too fast, the curtains will have begun to cover up the sensor, and only a narrow area of the sensor will be exposed to the full burst of flash. Each camera is designed with a maximum sync speed—the shortest shutter speed that will allow for proper flash exposure over the entire exposed sensor. The maximum sync speed for most cameras is between $\frac{1}{200}$ and $\frac{1}{250}$ second. The sync speed for your specific camera can be found in your user's manual. You can also Google your camera model to determine the sync speed or conduct a simple test, described in the sidebar on the facing page.

Slow Sync Speed. In almost every situation, you can choose to sync your flash at any speed below your camera's maximum sync speed. So, why would you want to do this? Well, once you add flash to an image, you really have two photographs in one: the flash photo, which is controlled mostly by the f-stop, and the background, which is controlled by the combination of the f-stop and shutter speed. You can also use adjustments in your shutter speed to change the appearance of your background in flash photographs. This technique often comes in handy in wedding photography. If I am at the reception and the venue is beautiful, I use a slow shutter speed so that I can better capture the background. However, if I am at the local VFW hall, with ugly paneling, folding metal

chairs, and fading photos of the past presidents in the background, I use a higher shutter speed to darken the background and hide what I don't want to see.

Using a slower shutter speed can also come in handy when you are using flash with ambient light.

Front- or Rear-Curtain Sync? You can choose to have your flash triggered when the front curtain exposes the sensor (front-curtain sync) or just before the rear curtain begins to conceal the sensor (rear-curtain sync). For faster speeds, like $\frac{1}{15}$ or faster, it probably won't matter which curtain you use. When you're working with slower shutter speeds, though, the sync option you select can have a big impact on the way the flash appears in the image. When you select front-curtain sync, the burst of flash occurs at the beginning of the exposure, and the ambient light continues to expose the sensor until the second curtain covers it. When you choose rear-curtain sync, the ambient light exposure occurs first, and the flash burst concludes the exposure.

When you are photographing moving subjects—for instance, a person running past your camera—using rear-curtain sync would allow you to record motion blur behind your subject. If front-curtain sync were used, the motion blur would precede the subject. This doesn't make sense visually. It can, however, provide for an interesting effect.

High-Speed Flash Sync. A few cameras and dedicated flash units are set up for high-speed flash sync. With high-speed sync, a rapid pulse of light rather than a brief burst of light is emitted. This rapidly pulsing light mimics continuous light and allows for the sensor to be exposed uniformly as the shutters move, as it would in non-flash lighting situations. The downside to this feature is that the flash power is diminished in intensity.

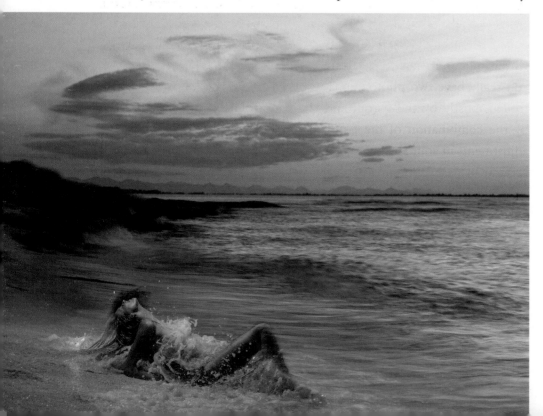

For this image, the model was in the water. I was also in the water, with my camera on a tripod, and we were both being jostled around by the waves. Exposure was f/5.6 at $\frac{1}{2}$ second and ISO 100. The camera was on manual. The flash, which was also set on manual, was in a softbox and positioned above and to the left of the young woman, 45 degrees from her face. If you look closely, you can see a little ghosting around her face and leg.

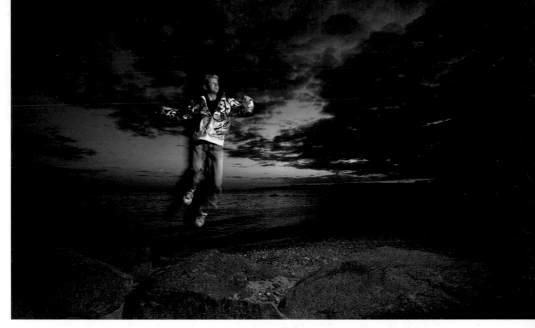

I had a great sunset and subject. I had him jump and captured the shot with a slow shutter speed and rear-curtain sync. I was able to get the desired result in just one shot. I love the dark shadows that resulted and the ghosting on his leg. The exposure was $\frac{1}{8}$ at f/5.6 and ISO 200. The focal length was 19mm.

Using high-speed flash sync allows you to reduce the existing light in a shot, giving you more control when mixing daylight and strobe. One of the most popular uses for high-speed sync is making your sky extra blue when you add flash to the subject. To get extra-blue skies, the flash has to overpower the normal exposure and underexpose the sky. To make this easy, shoot away from the sun (in the darker part of the sky), and/or shoot early in the morning or later in the afternoon, and/or have a more powerful flash—or two flashes. I designed the "Doug Box" modifier to accommodate a second flash just for this reason.

FLASH CAN STOP ACTION

I am sure you've seen photographs that capture, with incredible clarity, the moment some high-speed action peaks (e.g., a bullet meeting a latex balloon). That is called high-speed photography, and it is not done with a fast shutter speed on your camera. It is generally done in a darkened room with a very short burst of light. The Canon 550 EX flash, for example, can be set to $\frac{1}{32}$ power and can give you a shutter speed of approximately $\frac{1}{22,000}$ second.

As the section heading suggests, though, flash can be used to freeze action in many of the scenarios we face.

4. METERING AND EXPOSURE

When it comes to determining the correct exposure for a scene or subject, the trend today is to make a wild guess, then chimp (look at the back of the camera and make an "oooh, oooh" sound like a monkey when the image on the LCD looks somewhat like you thought it would). I am a big fan of using a meter. While I do use the LCD to confirm my exposure, I use my in-camera and handheld meters to determine what the exposure should be. I have learned my lesson about relying on the magic little screen. You see, sometimes the light conditions affect the appearance of the image on the screen, making you think you should recalculate your exposure. When you do, you discover that the image that looks fine on the LCD looks much different on your computer. There are other times when it is so bright outside that you can't clearly see the screen.

EXPOSURE BASICS

Every image is made with light. By manipulating the amount of light striking your image sensor, you can change the way the image is recorded. There are three variables that work together to create a perfect exposure: shutter speed, f-stop, and ISO.

Shutter Speed. The term "shutter speed" is used to refer to the length of time that the shutter remains open and the film or sensor is exposed to light. Typical shutter speeds range from 30 seconds to $\frac{1}{8000}$ second. A one-increment change in shutter speed will cut the amount of light creating the exposure in half (e.g., when going from $\frac{1}{125}$ second to $\frac{1}{250}$ second) or double it (e.g., going from $\frac{1}{125}$ second to $\frac{1}{125}$ second).

Aperture. The term "aperture" refers to an opening in a light-blocking plate inside the lens. The diameter of the opening is described in f-stops. A small f-stop number (e.g., f/4) is used to notate a large diameter opening. A larger f-stop, like f/22, is used to describe a smaller opening. If you change your aperture from f/4 to f/5.6, half as much light will enter the lens. Note that most modern cameras break the f-stops into $\frac{1}{2}$ or $\frac{1}{3}$ stop increments. This gives you more accuracy in your exposure.

Proper exposure is critical to acheiving a great image. Invest in a high-quality meter and use it to make sure your images are the best they can be.

Depth of Field. When you use a small aperture, more of the area between the closest and farthest image element is in focus.

Several factors will affect the depth of field in your image: (1) the size of the aperture, (2) the focal length of the lens in use, and (3) image size and its relationship to the subject distance.

Given the same subject distance and image size, the bigger lens opening (aperture) used (like f/2.8, f/2, f/1.4, etc.) will have a more shallow depth of field.

On the other hand, if you want more depth of field, you can just choose a smaller lens opening (like f/8, f/11, f/16, or f/22) to extend the plane of sharpness, so everything will be in sharper focus.

Remember the following relationships:

- The smaller the aperture, the more depth of field with the other two factors remaining the same. For example, if the lens focal length and the shooting distance stay the same, the depth of field is much deeper at f/16 than at f/2.8.
- The shorter the lens focal length, the more depth of field with the other two factors remaining the same. For example, comparing a 35mm lens with a 85mm lens at the same aperture and shooting distance, depth of field will be more with the 35mm lens.
- The greater the shooting distance, the more depth of field with the other two factors remaining the same. For example, if the subject is photographed from 4 feet and then from 8 feet, the zone of sharpness in the foreground and background is greater at 8 feet.

Another characteristic of depth of field is that it is typically deeper in the background than in the foreground.

ISO. An ISO is a film speed rating system. Low numbers indicate slow film (an emulsion with low sensitivity to light), and high film speeds indicate film that is quickly exposed. In digital cameras, the sensor's sensitivity to light can be manipulated by changing the ISO settings. (In reality, the sensor has only one sensitivity and, when you increase the ISO, you are stretching the info that is there. The software in the camera interpolates the information and fills in the blanks.) With film, the ISO is a measure of the sensitivity of the film to light. As the film speed increases, for example, from 100 to 800, the film needs less light to make a proper exposure.

It is important to understand that changing any one of the three settings will impact the effectiveness of the other two settings.

> It is important to understand that changing any one of the three settings will impact the effectiveness of the other two settings.

EQUIVALENT EXPOSURE

Once you have determined the settings you need to achieve a perfect exposure, you may find that you need to adjust one of the controls. As I mentioned in the previous section, changing one of the three settings will affect the other exposure settings too. For instance, if you were photographing a soccer player running down the field, you might decide to shoot at f/2.8 at $\frac{1}{500}$ second. You might then realize that the lens you brought to the game had a maximum exposure of f/4. An f/4 aperture allows half as much light into the camera as an f/2.8 aperture. Therefore, you would want to change the shutter speed to $\frac{1}{250}$, which lets in twice as much light as the original shutter speed, $\frac{1}{500}$. Because you wanted to freeze the motion of the running subject, though, you might need to use the $\frac{1}{500}$ shutter speed. Therefore, you would need to choose a faster ISO. Every time you halve or double a shutter speed or ISO, you change the exposure by 1 stop. So, in the above example, you could set your camera to ISO 200 and get proper exposure at f/4 at $\frac{1}{250}$. If you set your camera to ISO 400, you could shoot at f/4 at $\frac{1}{500}$ second. See how this works?

EXPOSURE MODES AND SETTINGS

Program. The camera sets the shutter speed and aperture according to the subject's brightness and a preset program built into the camera.

Shutter Priority. In this mode, you set the shutter speed and the camera sets the aperture according to the subject's brightness and the metering mode.

Aperture Priority. In this exposure mode, you set the aperture and the camera sets the shutter speed according to the subject's brightness and the metering mode.

Manual Exposure. You meter the subject (using the in-camera meter or handheld meter), and you set both the shutter speed and aperture. (This is my favorite option.)

Exposure Compensation. This feature allows you to set your exposure to up to ±3 stops different than the camera's autoexposure thinks the exposure should be. Exposure compensation is ideal for correcting in-camera metering errors caused by the subject's reflectivity. No matter what metering mode is used, an in-camera light meter will always erroneously underexpose a subject such as a bride against a white or light-colored background. Photographs like this will require +1 or more exposure compensation, whereas a low-key image may require negative exposure compensation.

Bracketing. The camera will automatically make three or five images when you click the shutter, with half of the exposures above and half below the normal exposure. You can set the stop difference between each exposure. For example, if you set the camera to 1 stop, bracketing will produce an image with correct exposure (0), –2 stops, –1 stop, +1 stop, and +2 stops.

METERING

Accurate exposure is fundamental to creating a high-quality photograph. There are two basic kinds of meters: reflected light and incident light.

Incident Light Meter. An incident meter is used to measure the light falling on the subject. To measure incident light, you place the incident meter at the subject and point the dome or disk toward the light source. This is the easiest way to get an accurate exposure.

To measure incident light, you can typically use a handheld meter.

Reflective Light Meter. Light bouncing off of a surface is reflected light. To measure reflected light, point the reflected meter (your camera lens) at the subject and read the light reflected off the subject.

In-camera meters are reflected light meters, and there are also handheld reflected light meters available. The recommended exposure can be swayed by the subject's tone or brightness level.

Spot meters allow you to measure the brightness of small areas in a scene from the camera position without walking over to take a close-up reading. Like reflected light meters, the recommended exposure can be swayed by the subject's brightness level. *(Note:* Sekonic offers a "combination meter," which functions as either a spot meter or an incident meter.)

USING YOUR IN-CAMERA METER

There are four different metering methods available on most cameras.

Evaluative or Matrix Metering. In this type of metering, the scene is split up into a grid of zones which are evaluated individually. The overall exposure is based on an algorithm specific to the particular camera, the details of which are closely guarded by the manufacturer. Often they are based on comparing the measurements to the exposure of typical scenes.

Spot Meter. A spot meter is center-weighted metering method that measures about 3.5 percent of the viewfinder. Spot metering allows you to meter the subject in the center of the frame (or on some cameras, at the selected autofocus point). Only a small area of the whole frame is

Every surface reflects light differently. A white surface reflects 90 to 100% of the light that strikes it. A black surface reflects only 1 to 5 percent of the light that strikes it. An 18 percent gray surface reflects 50 percent of the light that strikes it.

metered, and the exposure of the rest of the frame is ignored. This type of metering is useful for brightly backlit, macro, and moon shots.

Partial Metering (or Center Weighted). Partial metering is similar to spot metering, but in this method, the meter evaluates about 8 percent of the scene visible through the viewfinder.

Center-Weighted Average Metering. This method averages the exposure of the entire frame but gives extra weight to the center. It is ideal for portraits. This is the most common metering method used in point-and-shoot cameras, which don't offer metering mode selection.

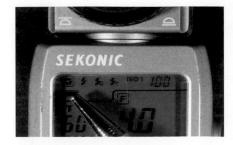
Ambient mode.

USING THE SEKONIC L-358 FLASH METER

This meter offers accurate flash and ambient light reading in both incident and reflected modes.

Metering in Manual Mode. To use the meter with your camera in manual mode, set your meter to ⅓ stop mode and turn on your meter. Next, set the meter's ISO to match your camera. Remember, the lower the ISO, the finer the image quality. Finally, choose available light mode or flash mode.

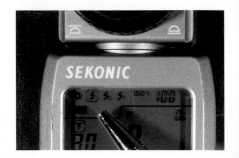
Flash mode.

Available Light. With your camera in manual mode, you'll be able to set your aperture and shutter speed independently. I pick an aperture and the meter will tell me which shutter speed to use. This is where the hand-held meter can be helpful.

Flash. There are three flash metering modes available on the Sekonic L-358:

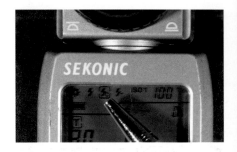
Flash with cord.

- flash—In this mode, you press the button on the side of the meter in order to prepare it to read the flash. Next, trigger the flash using the open flash (or test) button.
- flash cord—In this mode, you plug the PC cord from your flash into the PC connector on the front of the meter. When you press the button on the side of the meter, the flash will fire and read the flash intensity at the same time.
- flash with radio trigger—Sekonic has an accessory available for the L-358—a small PocketWizard transmitter that will trigger your flash when you push the button on the side of the meter, if you have a PocketWizard receiver attached to your flash.

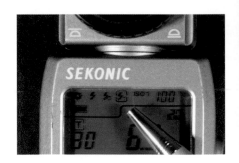
Flash with radio trigger.

Metering in Aperture Priority Mode. To use this meter in the aperture priority mode, press the mode button and turn the jog wheel until you

see the sun symbol encased in a box (this will tell you that your meter is set to available light mode). As you turn the wheel slowly (while you press the Mode button), you will see that the sun setting offers two subsettings: one where the "T" (shutter speed) is in a box, and the other where the "F" (aperture) is in a box. Turn the wheel to make the box land on the "F." This means the meter is in Aperture Priority mode.

Metering in the Shutter Priority Mode. Sometimes you want to pick your shutter speed and let the meter tell you what aperture you should use (this is helpful in sports photography). Here's how to do it:

While pressing the mode button, turn the wheel until there is a box around the sun symbol *and* a box around the "T". This will tell you that the meter is in available light and shutter priority mode. Now simply turn the dial (without pressing any other buttons) until you see the shutter speed you want to shoot at. Aim the meter's white dome at the light source or camera position and press the activation button once. The display will show you the recommended aperture setting.

THE EXPOSURE CALCULATOR FOR DIGITAL PHOTOGRAPHY

The Exposure Calculator for Digital Photography was designed to help you understand how the three components of exposure work together.

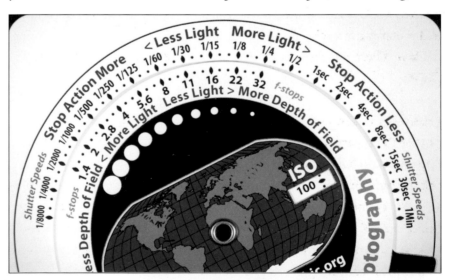

Top—The exposure calculator is a great tool that will help you find the correct aperture, shutter speed, and ISO combination that will suit any lighting scenario and subject. **Bottom**—The back of the card features an exposure target.

To use the calculator, you first select the ISO that you will need to use for the shot. Next, you take a meter reading of the light on the scene and enter the resultant f-stop and shutter speed into the calculator.

Let's consider a hypothetical shoot to illustrate how the calculator works. I entered ISO 100 because I wanted the best-possible image file my camera could record. Because I planned to shoot with my camera on a tripod, using a fast exposure would not be a problem. My meter reading was $\frac{1}{30}$ at f/4. I could use that reading if I wanted a shallow depth of field. If I wanted the maximum amount of depth of field, I could choose f/22 at 1 second. Each combination will produce a correct exposure.

Let's say that I want a lot of depth of field, so I would choose an f/11 aperture. But when I saw that, at ISO 100 and f/11, I would need a $\frac{1}{4}$ second shutter speed, and didn't have a tripod, I would be forced to find an equivalent exposure.

To get the shot I wanted, I would have to increase the ISO. Increasing the ISO from ISO 100 to ISO 200 would allow me to go from f/11 at $\frac{1}{4}$ to f/11 at $\frac{1}{8}$. If I feel that it is still not fast enough I can increase my ISO to 400 and that will increase my shutter speed to $\frac{1}{15}$. ISO 800 would allow me to go to $\frac{1}{125}$ in the above situation. Here you can see how the three elements work together. If you would like to own an exposure calculator, go to www.exposurecalculator.com. It comes with an 80-minute DVD that plays on your computer and explains how this whole thing works.

When you turn the exposure calculator over, you'll find an exposure target. This will help you achieve the right exposure and correct white balance.

LIGHT IS CUMULATIVE

One thing to keep in mind is that light, no matter the source, is cumulative. For example, if you are working in a dark room and flash the subject twice, the subject will be brighter than if you fired the flash only once. If you use an on-camera flash with an off-camera flash, the light from the two flashes will be brighter than light from one source—and if there is ambient light in the room, whether from a lightbulb or window light, that light will also add to the overall exposure. This is great because it means you won't need as much flash to get the correct exposure.

For the most part, you can meter these lights separately and predict the outcome. Also, you can use the shutter speed to control the effect of the ambient light.

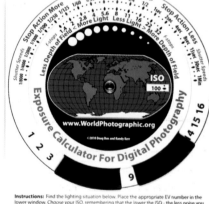

The exposure calculator is available with an 80-minute video presentation that explains metering, equivalent exposure, and the relationship between f-stop, shutter speed, and ISO. It is available at www.dougbox.com/shop/.

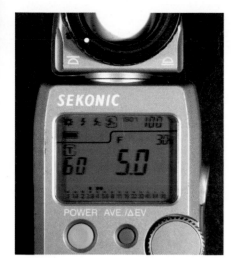

The meter's screen tells you a lot more than how to set your shutter speed and aperture for the proper exposure.

The biggest advantage of using the Sekonic L-358 meter in combination with the PocketWizard radio trigger is the ability for the meter to fire the flash for metering the light because you can add a PocketWizard chip in the meter.

METERING YOUR FLASH WITH THE POCKETWIZARD CHIP AND POCKETWIZARD PLUS II

To meter your flash using the Sekonic L-358, with the PocketWizard chip installed and a PocketWizard Plus II on the flash, hold down the mode button, turn selector knob clockwise until you are between the flash C mode and flash antenna mode. A number will blink. This is the channel indicator. Release the mode button. Next, turn the selector knob until the desired channel appears in the window. (The PocketWizard Plus II allows you to choose from channel 1, 2, 3, or 4. All four channels work the same. The only reason to choose one over the other is if another photographer is working using the channel you selected.)

Next, hold the mode button down again and turn the selector knob clockwise one click to the flash antenna mode. Set the same channel on your PocketWizard.

When you push the trigger, the flash will fire.

When metering the flash and ambient light together (for the ambient fill method), first meter the ambient light in the ambient light mode (e.g., f/4 at $\frac{1}{60}$). Next, switch the meter to the flash antenna mode. Set the shutter speed to match the meter reading (e.g., $\frac{1}{60}$). Push the button to fire the flash. The resulting reading will be a combined reading of flash and ambient light.

In the image above (top), the final reading was $\frac{1}{60}$ at f/5, $\frac{2}{3}$ stop more than the ambient reading of $\frac{1}{60}$ at f/4. Perfect. Notice two things: at the bottom of the window there is a graph with f-stops. There are three small lines above the numbers. The first one represents the flash part of the exposure. It is above 2.8. The second line indicates the ambient reading. It is above f/4 and the final reading is above f/5. This is the combined reading.

Also notice that 30% appears in the upper-right area. This tells you that 30% of the exposure is from flash and 70% of the final reading is for ambient light. This is about the percentage of flash that I like in my ambient fill images. There is not too much, not too little—it's just right.

CANON'S FLASH EXPOSURE LOCK

When I am faced with a scene in which there is a beautiful sunset but no light on the subject, I bring out my trusty softbox and Canon 580 EX II flash. Many times the subject will be small in the final image, so using the automatic flash setting or TTL metering with the on-camera flash will be a little tricky. My favorite way to make this image is set my off-camera flash to manual and use the flash exposure lock with the on-camera flash (this is a great feature that is available on the EOS series and 40D and up). This feature is perfect when the subject only occupies a small area of the image or if you are using a very wide-angle lens. It is also useful if the majority of the image is very dark or very light and the exposure of the subject will be thrown off by the subject's clothing or the surroundings.

The flash exposure lock allows you to measure just a small part of the scene and to take a pre-flash reading off a small area of the scene, such as a person's face, rather than the whole scene. The camera locks that reading into memory, recomposes the shot, and takes the image. To use it, place the center focus point on the part of the image you want to use for the exposure, push the AE lock button (40D and up) or the FEL button (EOS 1-D and higher). The pre-flash will fire, locking in the exposure for 16 seconds (the length of time can be changed). In this instance, –3 would give you just enough exposure for a fill light. Some Nikon flashes have a similar button on the flash.

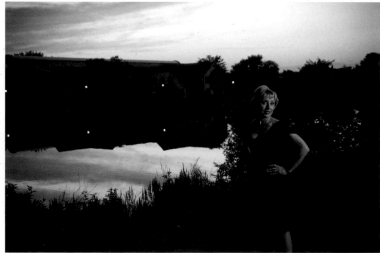
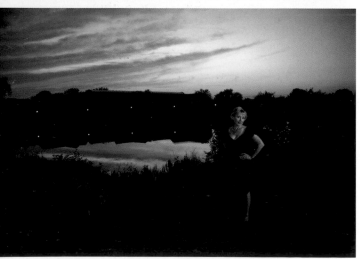

Top left—This image was made without flash. **Top right**—Off-camera flash only. Note how dark the shadow side of the face is. **Bottom**—The final image, made with the addition of on-camera flash, set at –3.

5. PORTRAITS

I sell a handy little device called the Light Finder that will help you see the direction of light. It's available at www.dougbox .com.

PROPER FLASH PLACEMENT

When using battery-powered flash, you are working without the benefit of a modeling light, a fairly weak continuous light source located near the flash tube that allows you to see the light effect that will be created when the flash fires. Therefore, you must know how to set up your lights to achieve reliable, repeatable, flattering results.

When lighting for portraits, we have two basic goals: In most cases, we want to create catchlights in the eyes at the 10 and 2 o'clock positions (there are always exceptions), and we want to make sure that the shadow from the nose falls toward the corner of the mouth.

If you think about it, there are only two positions where the light can be placed to fulfill both of these requirements. I call it the 45°/45° position. To find it, hold your left arm straight out to your side and hold the right arm out directly in front of you. Your arms will form a 90° angle. The point midway between your arms would be the 45° point. Now, with your left arm in the same position, move your right arm above your head. The point midway between your two arms is the second 45° point. This is the ideal placement for the flash in most situations, no matter which side of the face you are lighting from. Look at the diagram on the following page. This may help you to better visualize the ideal setup.

As you read through this book and come across some photos showing the position of the softbox, you will note that the height of the softbox

EXCEPTIONS TO THE RULE

Some battery-operated flash units do come equipped with a modeling light. I own a Lumedyne unit and the ProPhoto Acute B600, and both have modeling lights. Both are good units, but the modeling light on the ProPhoto is much brighter. The Lumedyne, however, can be modified to increase its power output. Though having a modeling light is a nice benefit, be careful: it can run down your battery quickly.

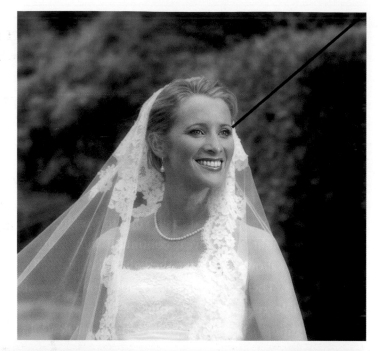

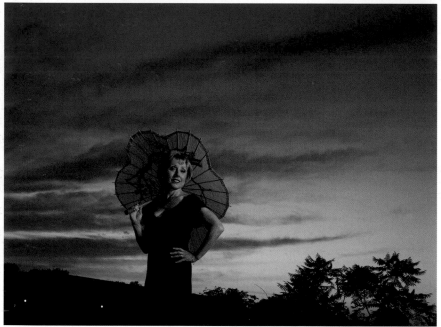

Top left—The black line indicates the ideal angle of light for portraiture. If the bride shown here were to lower her chin, note that you would need to lower the light position. **Top right**—This diagram shows the 45°/45° angle of light, the preferred flash position for portraits. **Bottom**—Draw an imaginary line outward from the subject's nose, and you can see that the right side of the face is narrower ("shorter") than the left side. Since the light is coming from this side, this is called short lighting.

varies. Keep in mind that as the light's distance from the subject increases, you will need to raise the light source higher to get it in the 45°/45° position. Likewise, if the subject raises or lowers her head, you will need to lower or raise your softbox to get the correct lighting.

Another concern when lighting portraits is determining which side of the face to place the light on. I like to use short lighting on my subjects, as it slims the face. The caption supplied with the image above (woman with parasol) shows how this is done.

The images that follow were captured just after sunset. The light had become dull, but because the sky was brighter in the area where the sun went down, there was still some direction to the light.

The first image shows how bad the lighting in your image can look when the light is coming from the wrong direction. Here, the softbox was placed to camera right. It filled in the shadows created by the ambient light, creating a flat, unflattering look.

The second image was made with available light only. The exposure was .03 second at f/8 and ISO 100. There is no particular reason why I set the aperture to f/8. I could have used f/4 and a faster shutter speed,

Top left—Here you can see how bad the light is when it comes from the wrong direction. See how unnatural the image looks? **Top right**—This image is not bad, but the eyes are dead, and the skin has a blue gray tint. **Bottom**—Next, I added off-camera flash. You can see how the flash cleaned everything up, added definition, and illuminated the mask of the face.

but I thought I might get some motion from the water at the lower shutter speed. I was using a tripod, so the slow shutter speed would not be a problem and I was using a radio remote control to fire the shutter—an added security against camera shake. I used ISO 100 because I was shooting a Nikon D 200, which has a tendency to have a bad noise problem at ISO 400 or more, especially in low light situations. The second image doesn't look too bad, but the eyes were dead and the existing light caused a blue-gray tint in the image.

Now, let's look at the third image. As you can see, I added off-camera flash in a softbox and positioned it high at camera left. Because Tammy tilted her head back, the light was probably a bit low in this case.

The fourth and final image is a cropped version of image three. Look at the differences between the on-camera flash image, the existing-light-only shot, and the final photo. You can see that flash provided a much more flattering, dimensional lighting effect—and it cleaned up the color as well.

Unusual Flash Positioning. Now let's look at another series of images of the same model. I had Tammy lean back on her arms and look up. The first shot was made with on-camera flash only. This is a very unprofessional look.

Next, I introduced the flash in an unusual position—high above and behind the subject on the far side of the subject. Note though that the light is still the 45°/45° position. Placing the light to the right of the subject meant I would be photographing into the shadow side of her face. I love the way the light almost looks like moonlight with the dark sky. The exposure was still 0.3 second at f/8 and ISO 100.

The final image shows the results of a little postproduction work. I used Photoshop's Liquefy tool to "tuck in" the tummy a bit, darkened the edges, then added the brown line and black border.

ONE-LIGHT PORTRAITS

Working with flash can make shooting on location less of a hassle. Prior to using off-camera flash, I used to have to bring two or three power heads, a couple of umbrellas, light stands, and a sack full of cords to every location. The setup and teardown would take 30 minutes. Now I bring in one off-camera flash in a softbox, a lightstand, a tripod, and my camera. I can carry everything in one trip, and the setup is a snap. Since I've begun working with flash, I'm more relaxed when photographing a session, and I love the results. The images are more natural looking.

Since I've begun working with flash, I'm more relaxed when photographing a session, and I love the results.

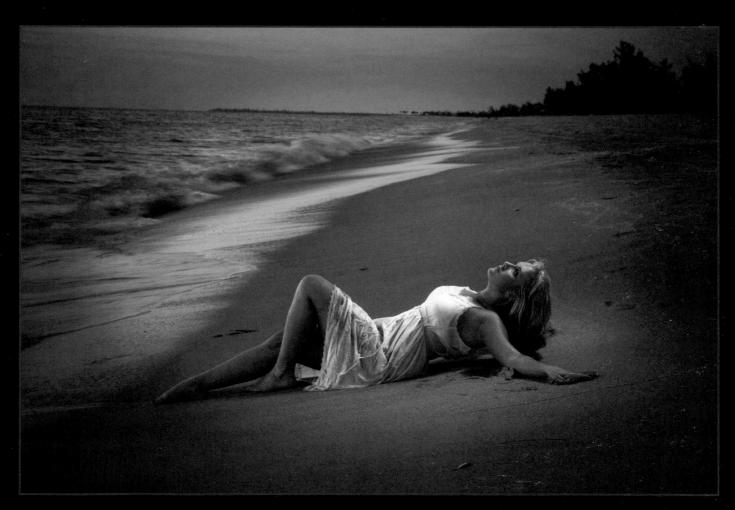

Top left—Using on-camera flash resulted in an amateurish image. **Top right**—Here, I had the flash positioned high above and behind the subject's head, still at a 45 degree angle. Note the beautiful result I was able to achieve using this unusual light position. **Bottom**—Here is the image created with the off-camera flash. I used Photoshop to do a little retouching and to create the brown line and black frame.

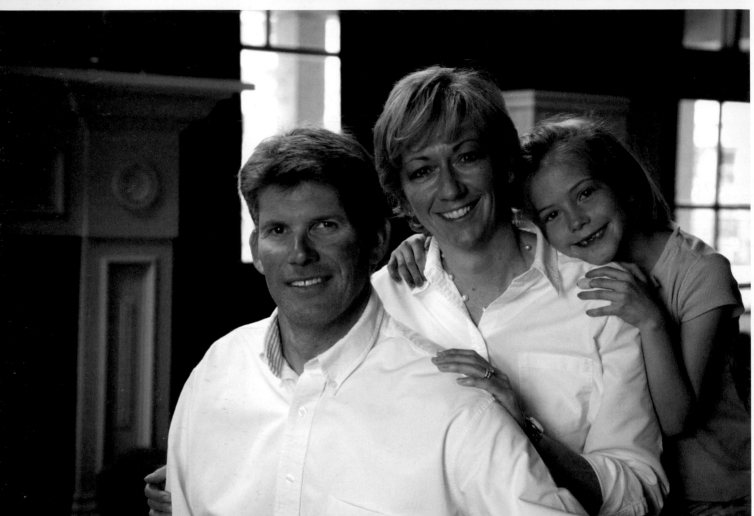

In one-light flash setups, the ambient light, which comes from windows, doorways, and existing light fixtures, provides the fill. As this light fills the room, it illuminates the background of the portrait. With everything in the room already illuminated, when I bring in the subject, I simply need to add light on him or her. Let's look at a couple of images that illustrate this technique, which I call the ambient fill method.

To create these images, I metered the existing light and added the flash at $^2/_3$ stop over the ambient exposure.

The Ambient Fill Method. Let's take a closer look at how the ambient fill method can be used to create beautifully lit, salable images in no time. Here's a step-by-step look at creating a one-light image on location. I've chosen some images of a beautiful bride to illustrate this approach.

- Analyze the scene. How bright is the background? Is the ambient light level sufficient to allow you to show details of the background in the portrait? If so, are there elements in the background that will draw the viewer's eye away from the subject?
- Decide where to place your camera. Consider where the subject will be posed and the direction in which the subject's face will be turned in relation to the camera.
- Calculate the proper placement for the softbox. Remember, ensuring that the light unit is at the 45°/45° position will enable you to

Above—The setup for this beautiful image was simple. I used one small softbox with a battery-powered flash, two PocketWizards, one light meter, and a camera with a tripod. **Right**—You will notice that the subject's face, part of the dress, and flowers are lit by the off-camera flash, housed in a softbox. I made sure the face of the box was position flat and parallel to the subject, and placed it at the 45°/45° position. With the light in this position, I was able to achieve beautiful light on the face and a nice falloff on the gown.

record catchlights in the desired 10 o'clock or 2 o'clock position. We want to light the mask of the face (eyes, forehead, nose, mouth, and chin), letting the side of the face closest to the camera fall into shadow.

- Meter the ambient light at the subject. Add flash so that the final (combined) reading is $^2/_3$ stop over the ambient light exposure reading.

I used a softbox to simulate the appearance of window light in these images.

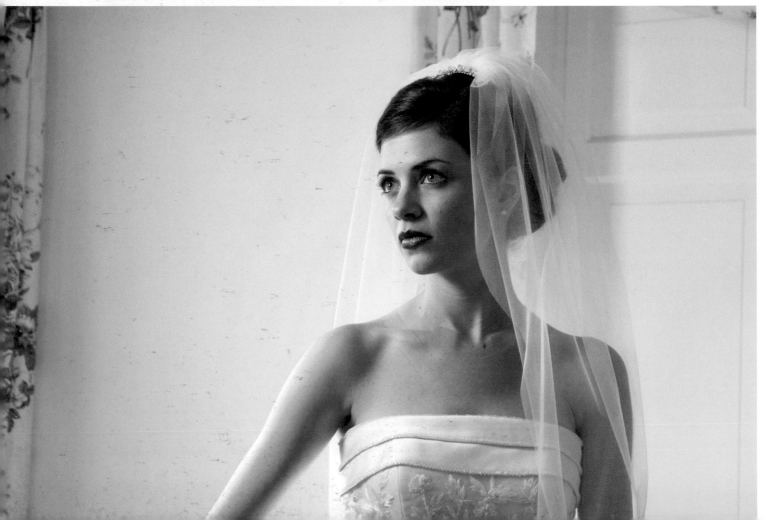

Top left—Here we have an image made with only ambient light. **Top right**—The final image was made with off-camera flash as the main light. What a difference! The setup for the shot took less than five minutes. That makes me smile. **Bottom**—Because I was shooting at night, the ambient light level in this image was low. I used a slow shutter speed to record more detail in the background and used a gel to correct the color temperature imbalance between the existing light and the flash. (You'll read more about this technique in chapter 6.) Look at this photograph. If I wanted the background to be darker, what would I do? Right, a faster shutter speed would make the ambient light less prevalent in the photograph, and the artwork on the wall would be darker.

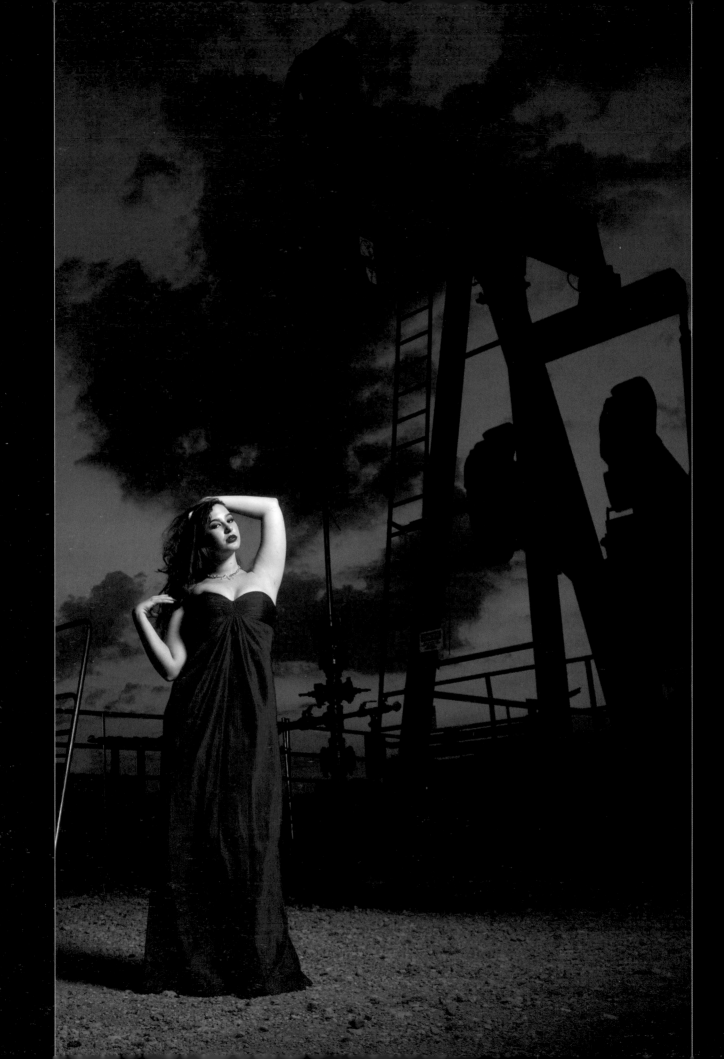

Facing page—A beautiful model in a great dress in an industrial scene. How much fun! The off-camera flash was placed just out of camera range in the 45°/45° position. The image was shot at f/6.3 and ¹/₂₅ second and ISO 100. **Left**—The light was coming from overhead, and I positioned the kids with the sun behind them. There was plenty of light, but the light on their faces was not good. There was no life in their eyes and there are dark shadows visible under their eyes. Also note that their skin tones are not correct. **Right**—All of these flaws could be corrected with an off-camera flash. The final image shows a big improvement.

OUTDOOR PORTRAITURE

People who haven't had much experience with outdoor portraiture tend to think it's easy. There is light everywhere, so it must be a matter of posing the subject and pushing the shutter button, right? Well, unfortunately, things are a bit more complicated than that. Let's look at some of the ways that photographers can use flash to solve the problems they often encounter when photographing their subjects in natural light.

Improve the Light. One of the biggest problems with outdoor portrait photography is sometimes the light is great, and sometimes it is not. The quality of light can be affected by the atmosphere, buildings, trees—and you've got to find a way to create good, flattering lighting despite the obstacles.

Let's look at a few examples that show how we can overcome the challenges presented by the ambient light on the subject and in the scene.

When we're working in the studio, we have complete control over our lighting. Outdoors, we must find a way to work with what we have. Sometimes the light does not come from the desired direction.

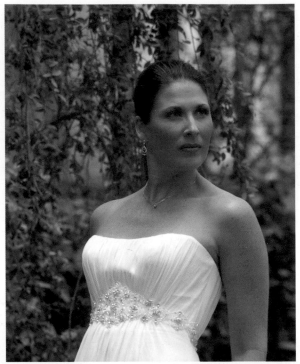

Left and right—Most of the light on this bride came from directly above her. When we zoom in to look at her face, we can see the unflattering effects of the top light. There are dark shadows under the woman's eyes. Also note that the light from the top of the image to the bottom is even. We can do much better than this. By putting the box in the 45º/45º position with the face of the softbox parallel to the subject, we perfectly illuminate the face while not overlighting the shoulder and the body, because of the way light falls off from the softbox.

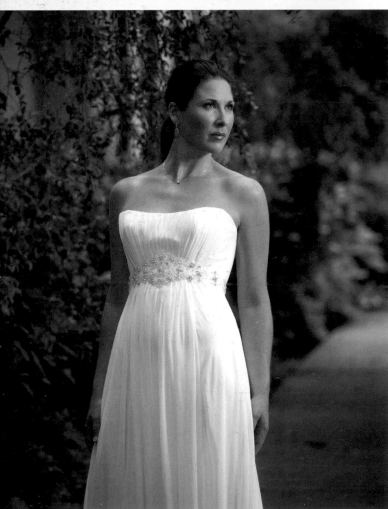
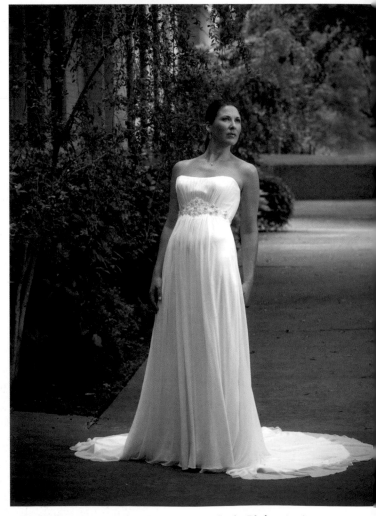

Left—In this image, we have beautiful light on the bride's face. This light was created with off-camera flash. **Right**—In this image, the light is most intense on the subject's face and it softly falls off as it spills down her body. This draws your attention to the bride's face but still lights the dress. It also does not overlight the shoulder and arm. *(Note:* No postproduction work was done on these images, and, with good lighting, they are salable as is. What a time saver!)

Top left—Here is the original image, made with available light only. **Bottom left**—This image shows the setup. Note the placement of the flash. When you're working with flash, getting it as close to the subject as possible, while keeping it outside of the frame, will produce the softest, most flattering light. **Right**—Here is the image made with off-camera flash. The light on the face is more flattering, the dress looks better, and even the appearance of the flowers has improved. The skin color is better, and it doesn't look "flashy." The exposure was f/6.7 at $\frac{1}{125}$ and ISO 400. In retrospect, I feel that the softbox was placed a little low.

Let's look at a real-life shoot and review the steps I took to ensure good lighting on my subject.

The Antique Rose Emporium in Independence, TX, is a beautiful backdrop for bridal portraits. *(Note:* Always call ahead to ask staff if it's okay to take photos at the desired location before heading there to do session work with a client.) While the location is beautiful, the light was coming from above and was a little too blue.

Having identified the issues with the lighting, I devised a plan. I posed the bride with her body facing camera left, where a building on the

grounds blocked some of the light. I had her turn her head back toward camera right, which is where I placed my flash, housed in a softbox. The flash would clean up the color, add directional light, and illuminate the mask of the face. I would direct the light at the short side of the face, leaving the broad side of the face in shadow. This would allow for a slimmer presentation of the face.

Now, let's look at another scenario (page 67) and see how I was able to improve the light in another location.

The scene of this shoot was another beautiful location: the Dallas Arboretum. The bride was lovely, but the light wasn't perfect. Most of the light in the scene was filtering through trees and bouncing off of the ground. In other words, there was lots of light, but it wasn't *good* light. With our newfound understanding of light, we don't have to be afraid of bad light. We can make it work for us.

As you can see in the first image, in this scene, there was light all around. In the sunset images discussed earlier, the subject and background were lit differently, but here, they are lit the same. In this scene, the diffused ambient light provides our fill light. It is nondirectional, fairly flat, and lights everything, even the background.

Since we already have great fill light in our scene, we will need to add a main light. (I call this approach the ambient fill method.) This was a fairly low light situation, and there was not enough light to reflect onto the subject, so a reflector would have been ineffective. Adding a flash, housed in a softbox, would be our best bet.

My first goal was to meter the fill light. I used a handheld incident meter in the ambient mode and held it at the subject's position, and pointed it toward the camera. The fill light reading was $1/80$ at f/4.5 and ISO 100.

Next, I needed to add the main light. I have been using the ambient fill method for almost twenty-five years—long before digital photography provided the ability to check your images on an LCD screen. I had to learn how flash and ambient light reacted with each other and added together. I experimented a lot, took a lot of meter readings, looked at the final results, and developed likes and dislikes. I came to the conclusion that to accomplish the look I was after, I would need to add enough main light to give me a combined ambient and main light final meter reading of $2/3$ stop more than the ambient light reading. Here is how it is done: *(Note: My camera and flash were in manual mode and the flash was housed in a softbox.)*

CREATING BEAUTIFUL LIGHT
Combining flash with ambient light makes your photographs come alive. There is nothing greater than photographing a subject against a beautiful sunset, with off-camera flash serving to add light on the subject. The lighting in the final image is even prettier than it appears to the eye.

1. I metered the ambient light using the incident meter. In this case, the reading was $\frac{1}{80}$ at f/4.5.

2. I changed the metering mode to flash, then used the shutter speed obtained in the ambient reading. This is very important. By setting the shutter speed the same as the ambient reading, the meter will

Top—The ambient light in this scene provided fill for the image. To improve the shot, we needed to add a main light to create a directional source and yield a more professional-looking image. **Bottom**—The main light added direction to the light.

Top left—In this situation, all of the ambient light that was falling on the subject had filtered through tree branches, creating a green color cast. **Top right**—Here is the setup, showing the flash inside of a softbox. My meter recommended an exposure of $^1/_{50}$ at f/5 and ISO 200. **Bottom**—Here is the final image. As you can see, using the modified off-camera flash resulted in a softer, more natural lighting effect.

add the flash and ambient light together. In this situation, the shutter speed was $\frac{1}{80}$.

3. I metered the flash. I wanted the combined reading to be $\frac{2}{3}$ stop more than the ambient reading, or $\frac{1}{80}$ at f/5.6. If the reading is more, I turn the flash down and re-meter until the combined reading is exactly $\frac{2}{3}$ stop over the ambient reading.

My goal for using off-camera flash with the ambient fill method is that you don't see the flash. It should look natural.

Let's explore this further. Whenever I am faced with a situation in which the light has no direction, the light is not clean, the color of the light isn't good, or there is a lot of top light, I use off-camera flash. On page 68, there are a trio of images that show how I was able to use flash, housed in a softbox, to turn a bad lighting situation around. The softbox diffused the hard light, making the light look more natural and flattering.

When you look at the setup shot, you will notice that I had an assistant hold the light stand. This is because there was a breeze that was just strong enough to blow the box down. When I am working alone and am faced with this situation, I place the softbox, set up on the stand, on its face. The "Doug Box" modifier has a recessed face. I know that if it is lying on the ground, it can't fall over. I leave it down while I am getting ready, posing people, setting up the camera, and stand it up when I am ready to make the exposure.

Another strategy I use when the winds are light is to leave one of the collars on the stand slightly loose. That way, when the wind does blow, the softbox will turn into the wind. That is one of the biggest advantages to a softbox over an umbrella. An umbrella will actually turn in to catch the wind and sail away, more than likely destroying the umbrella and the flash. The softbox provides some protection.

I also use an inexpensive yellow plastic tent peg I get from Walmart to secure the light. I push it into the ground with the small hook over one of the braces on the light stand. You can also use a sandbag to help anchor your light. I get mine from Kinesis Gear (www.kgear.com). These are great if you are not too far from the car when you stop to make the photo (a sandbag can quickly feel heavy).

When you are working outdoors, find the best light you can and make it better. That is exactly what I did when photographing a couple with their car. Let's look at the lighting scenario (see page 70).

When you look at the first image of the couple, you can see that there was a lot of light coming from camera right. There was also a lot of top light, which created dark shadows under the subjects' eyes. That told me,

Top—Here is the image made with only ambient light. We can do much better than this. **Bottom**—To enhance the lighting, I placed my flash in a softbox to camera right and feathered it off of the closest subject. The exposure was f/8 at $\frac{1}{125}$ and ISO 200. Note that I sometimes choose to work at ISO 200. My preference is ISO 100, but I tend to shoot at ISO 200 when running workshops so the students can use the same settings (not all camera models offer an ISO 100 setting).

get the softbox. I could have placed the softbox on either side of the camera, but since the natural light was coming from camera right (because of a building on camera left) I placed the light on camera right. That way, I didn't have to overpower the existing light just to make the two light sources equal. I also feathered the light off of the closest person so that the closer subject did not receive more light that the farther subject. After

you do this for a while, you learn to eyeball the outcome of feathering the light, but when you are starting out, it is best to check it with your flash meter. Simply meter both subjects, and if the light is still brighter on the closer person, angle the light farther away from him or her.

Let's look at another lighting scenario now. Let's look at the "before" image and analyze the light that was falling on the subject.

In this portrait location, there was almost no direction to the light falling on the young subject. We were deep in the woods, so all of the light was diffused through the trees. The ambient light served as fill, so we needed to add a main light.

To begin, I metered the ambient light. The exposure was $\frac{1}{125}$ at f/4.5 and ISO 200, measured at the subject. I placed the flash on camera right, switched my meter to the flash mode and measured the flash, remembering to set the shutter speed on the meter. The first reading was f/11 at $\frac{1}{125}$, so I turned down the flash. The second reading was f/7.1. I turned the power down a little more and made the final reading. It was $\frac{1}{125}$ at f/5.6 ($\frac{2}{3}$ stop more). I set that reading on my camera and made the exposure.

Left—This image was made with ambient light only. **Right**—Here is the enhanced image, made with flash. The exposure was $\frac{1}{125}$ at f/5.6.

THE MAGIC OF MANUAL MODE

Here is what is great about shooting manual: I can change subjects, move the camera closer or farther away, and even change locations—as long as I keep the flash-to-subject distance the same, I don't have to re-meter.

Top—The original image. **Bottom**—Here, I used a flash in profile position to enhance the light on the subject. All that remains to make this a salable portrait is a bit of postproduction work to remove the light source from view.

Now, let's look at another pair of images. In this session, I found an interesting place to pose my subject, but as you can see, there was no light on her. I placed the flash in the profile position, back in the bushes to get great light on the subject. I left the light in this image to show its placement. I could quickly clone some leaves in postproduction to remove all evidence of artificial illumination.

Note: Because the line of sight was interrupted by the foliage, I used a PocketWizard Plus II to trigger the off-camera flash in the softbox.

Next, let's look at a picture of two young sisters. I found a perfect little cove to place the girls. It had some foreground elements that would add depth to the photograph and a nice background, but with a lot of top light, the scene was lacking good light. As you can see, the overhead light had been filtered through the trees, creating a green tint in the skin tones. Simply adding flash made a subtle but important improvement in the quality of the image.

The same situation presented itself when I photographed the younger sister alone. I had found a great place for the girl to pose, but the ambient light had no direction. I needed to add flash.

Note that for the shot of the two sisters and the one of the younger sibling, I set my camera to the flash white balance preset. Note that almost all of the images in this book were made without any editing in Photo-

Left—Before flash was added, the light was weak and had a green color cast. **Right**—I added flash and set the camera to the flash white balance preset to clean up the color and add a little punch to the light, while keeping the effect natural. The exposure was f/4.5 at $^1/_{100}$ and ISO 200. The focal length was 200mm.

 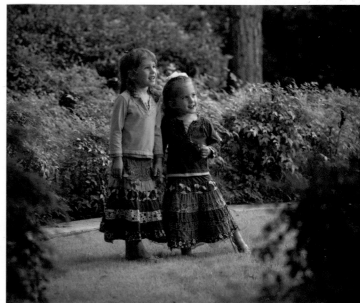

Here we have before (left) and after (right) images of the younger sibling. Though the location was different, the light was as it was in the in the original image of the girl and her sister.

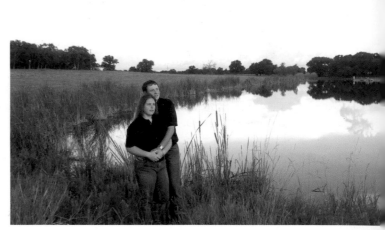

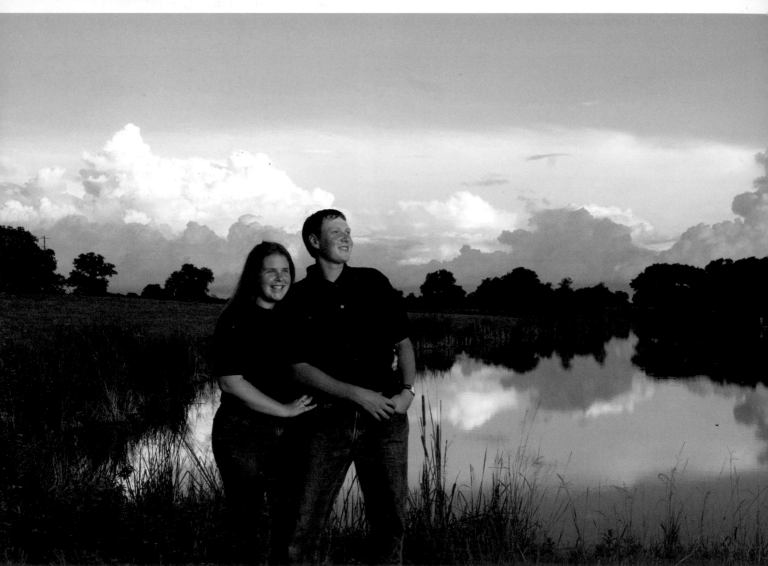

Top left—Here is the image properly exposed for the ambient light reading. The exposure was $^1/_{250}$ at f/10, at ISO 400. **Top right**—Metering at the subject resulted in an image with a washed-out background. The exposure for this image was $^1/_{125}$ at f/5.6 and ISO 400. **Bottom**—Here is the final image. The exposure was $^1/_{320}$ at f/10 and ISO 400.

The percentage that appears above the f-stop value on the meter's screen tells you how much of the exposure will be provided by the flash. In this case, then, 40% of the exposure would come from flash and 60% would be ambient light. If I am using the ambient fill method, I think images made with 20% to 30% flash look more natural. In scenes where the background is brighter than the subject, the percent can be 40 or more. If it is really dark, it can be 100%.

shop. If I did use Photoshop, I pointed it out. I shoot in RAW, and while I am converting the images from RAW to JPEG in Adobe Camera Raw, the program makes some preset enhancements in the background: I have the black set to +10, the saturation at +23, and I add vignetting at −85.

Let's move on to another lighting scenario. For my next session, I wanted to photograph a young couple outdoors and use the dramatic clouds as my background. In this situation, the background was brighter than the subjects, so I had to bring in flash to throw light on the subjects.

To make the dramatic final photograph, I simply metered the scene, set the camera for proper exposure on the background (in this case, $\frac{1}{250}$ at f/10 and ISO 400), and brought the flash in on the subjects at f/10. The final image shows the couple properly exposed, and the background looks great (using a shorter shutter speed yielded a more dramatic background). This shot was made without any postproduction work.

I am sometimes asked, "Couldn't you use high dynamic range processing (HDR; a technique in which software is used to take the best tones from a series of exposures and combine them in a single image) to get the image, or take one image with the proper exposure on the people and a second shot with the dramatic background and combine the desired elements to in Photoshop?" Well, not always—for two reasons. First, I might have been able to pull the clouds out, but the lighting on the face would have been flat and boring. Second, if I had shot a couple of dozen images in this same scene, it would have taken a lot of time to run them through Photoshop to make them consistent. I refuse to waste that time behind the computer. When I can, I just add flash and get it right in the camera.

Let's test your knowledge. On the following page, we have a pair of images shot on a sandy beach. Is the "before" image at the top of the page an ambient fill light situation, or is the background light more intense than the light on the subject? The fact that this is a sort of sunset image would lead people to assume that the background is brighter than the subject—but take a closer look at the image: the sand and water make up the real background. Therefore, we'll use the ambient fill method to get beautiful lighting on the subject. (I realize the "before" photo is not the same subject. I didn't take a "before" shot of the woman in the final image, so I used an image of another woman taken at about the same time.)

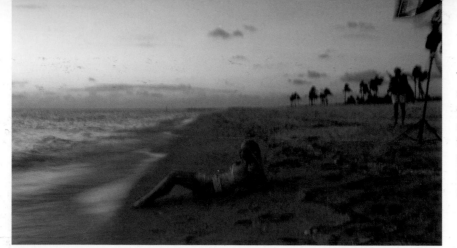

Top—This image was taken at the same scene and in the same location as the lower image. The ambient light alone does not make for a good image. **Bottom**—The final image shows much improved lighting. The final exposure was $1/20$ at f/5 and ISO 800. I used the flash white balance preset.

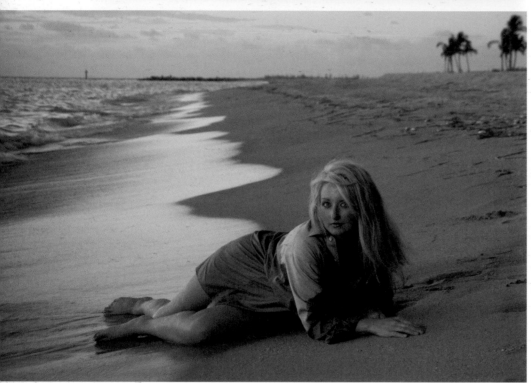

On the facing page, we have images taken under the Century Tree at the Texas A&M campus. Thousands of marriage proposals have taken place on this bench, in the shade of this tree. The background is definitely brighter than the light on the subjects. No light makes its way under the Century Tree, so I had to bring in my flash to add light on the subjects.

The background light was brighter than the light on the subjects. Earlier, I advocated the 45°/45° position and shooting into the shadow side of the face. As you can see in the second image, I chose a different flash placement this time. It was positioned on the far side of the woman and was feathered so that the light was strongest on her face and fell off over the length of her body. As the face is the brightest part of the scene, this is where the viewer's eye is first drawn.

Top left—In this image, you can clearly see that the background was better illuminated than the subjects. **Top right**—You can see the placement of the flash in the left third of the image. **Bottom**—Here is the final image.

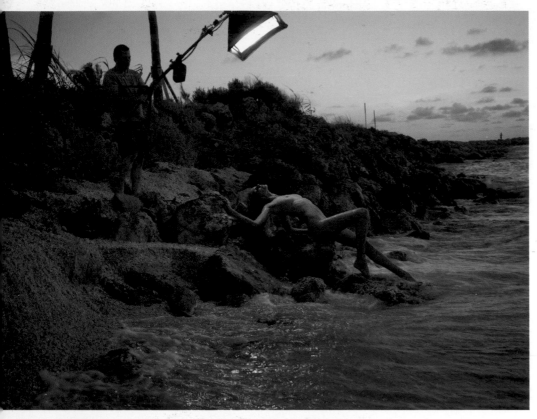

Top—As you can see in this setup shot, the light was placed just beyond the subject position and feathered so that the light would be brightest on the subject's face and gradually transition to shadow as it fell across her body. The light shown was the predecessor to the current "Doug Box" modifier. This light, made by a different manufacturer, is smaller, square, and takes about ten minutes to set up and tear down. I like the newer model better. It is a little larger, is octagon in shape (which gives a nicer catchlight), is of a better quality, and can be set up in seconds. Plus, I make sure you have all the parts you need to make it work for most flash units. **Bottom**—Here's the final image. The exposure was f/8 at $^1\!/_{125}$ and ISO 100.

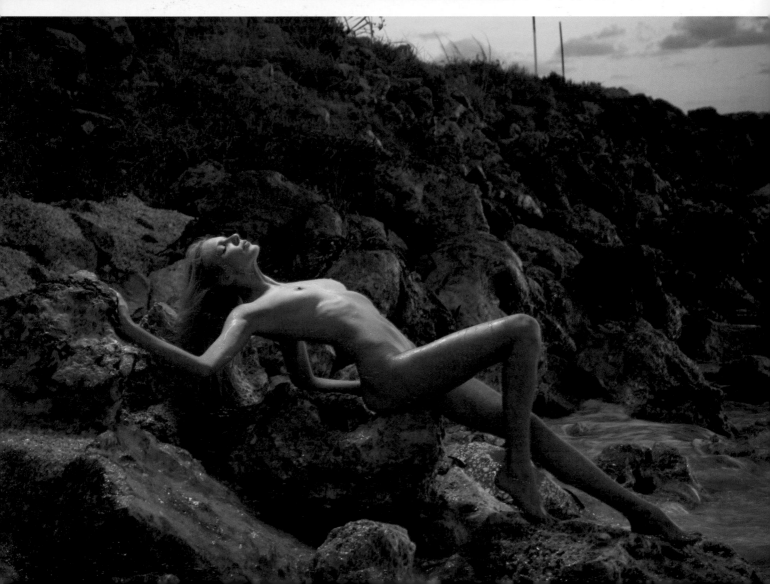

Left—The lighting in this scene was bright sun with a little haze. **Right**—I added flash to bring up the light level on the children, creating a more polished and professional lighting effect. The exposure was f/8 at $^1/_{125}$ and ISO 100.

Shooting in Bright Sunlight. I get a lot of questions about photographing people in bright sunlight. I have to tell you, it is my least favorite shooting condition. I will do anything to not photograph outdoors in the middle of the day. First, I live in Texas. It is hot in the middle of the day almost half of the year. It is bright and everyone squints, including me. The light is harsh and unflattering, and it is difficult to overpower the bright sunlight with flash.

There are a few times when you're likely to find that shooting in bright light is your only option. For instance, if you're on vacation in Disney World and want to photograph the kids in front of the Magic Castle, do your best to backlight the children and use your on-camera flash to pump as much light as possible into their faces (you probably won't have an off-camera flash handy when you're on a family vacation). If you can't backlight the subjects, try to place them in the shade and add light with your on-camera flash.

When my boys were younger, I did lots of sports photos. Many were done with just the available light, but sometimes I added on-camera flash.

Left—Here is the location where I chose to pose my subjects. The mid-afternoon sun was bright, the sky was a vibrant blue and there were white, billowy clouds. My first step was to meter the background. **Right**—Next, I placed my subjects. Clearly, the background light was brighter than the light falling on my subjects.

Left—I brought in a flash housed in a softbox, at the 45º/45º position on camera left. **Right**—The final shot shows a much better, more balanced lighting effect.

Whenever you are shooting in these conditions, the recommended approach is simple. Meter the background with your in-camera meter, then bring the flash up to the same exposure.

Now, you may find that you're draining your batteries quickly when you're working this way, especially if you use a modifier like a softbox to diffuse the light. Once I have set up the shot, I put the flash on full power and move it closer until I get the desired brightness.

Now, let's look at another situation. Here we have a couple posed in the middle of the afternoon. I took this image at about 3:30PM. The sun was bright and the sky was a bright blue, with white billowy clouds. I did not position the subjects in the bright sun because my posing options would be limited if I was trying to keep the sun off their faces. Along the street, I found the shade of a tree, metered the background using my

in-camera meter, placed the subjects in the shade, and metered the flash. Next, I set the shutter speed on the meter then set the flash to match the background reading. I couldn't raise the light up as high as I wanted to because there was a tree limb in the way, so I simply tilted it upward. This created a perfect falloff of the light.

Below are two more of the photos I shot during this session. This went very quickly because I was shooting in manual mode and nothing had changed. I just moved farther from the subjects when I added people to the shot. I never had to re-meter or even look at the back of the camera.

Here are two more images, created under the same shooting conditions and using the same exposure. Since I was shooting in manual mode and nothing had changed, all I had to do was change my camera-to-subject distance to suit the size of the group. The exposure was f/10 at $1/125$ and ISO 200.

Top left—Fill light only. The on-camera flash was set at −2, which will render the subject 2 stops underexposed. **Top right**—Same scene, different subject. This shot was made with off-camera flash only. The flash was used in manual mode at the 45°/45° position and parallel to the subject. See how it lights the face but does not blow out the clothing. **Bottom**—Main and fill light were used together in this shot. Using both lights brings the image together.

Adding a Fill Light. In situations when the background is brighter than the subject, I add my main light at the 45°/45° position and create short lighting on the subject. In some applications, though, the shadow side of the face is too dark. If I were shooting in the studio and wanted to add light on the shadow side of the subject's face, I might use a reflector to lighten the shadows. When working outdoors, however, using a reflector to create fill light is difficult. Because you will likely be working with a flash unit without a modeling light, it can be difficult to properly angle the reflector to catch the light from the flash and direct it precisely to fill the shadows on the subject. A better option for lightening shadows when shooting outdoors is to introduce a fill light.

When adding a fill light in the studio, it is commonly positioned above the camera. In this position, it provides an overall shadowless light on your subject. The light from a fill light is, by nature, lower in exposure than the main light, so long as we use our on-camera flash at a lower power, it will serve nicely as a fill light. It is above the camera and provides a shadowless light (as long as the camera is in the horizontal position).

The easiest way to decrease the output of the on-camera flash is to use the flash exposure compensation feature. Check the user's manual for specific directions. See the sidebar for detailed information on using the feature on the 580 EX II.

Sometimes I Need More Light. I am always amazed at how often my shoe-mount flash will do everything I need it to do. These are amazing technological workhorses, but occasionally I need more power—this is often the case when I am photographing a group outdoors and am trying to overpower the sun. When I was photographing my family this year, I found a shady spot where the sun would be at the subjects' backs (see image page 84). I metered the background, which measured $\frac{1}{200}$ at f/6.3. I was using the PocketWizard Mini and Flex system, and my flash was in manual mode. Even at full power, I needed more light. I got out another flash and PocketWizard and simply used a rubber band to hold them together in the "Doug Box" modifier. That doubled the amount of light at my disposal and gave me the extra stop I needed to overpower the sun.

> The easiest way to decrease the output of the on-camera flash is to use the flash exposure compensation feature.

ADDING FILL LIGHT WITH THE CANON 580 EX II FLASH

With my Canon camera, I put the flash in the E-TTL mode. The default setting is 0 (no exposure compensation). To decrease the output, I simply press the small button inside the dial on the flash unit. The number 0 will blink. Turning the dial counterclockwise will decrease the amount of light the on-camera flash will produce. It is reduced in $\frac{1}{3}$ stop increments: –.3, –.7, –1, –1.3, –1.7, –2, –2.3, –2.7, and –3. (*Note:* With most Nikon flashes, push the "+" button to reduce the power.)

There is a flash exposure compensation button located on many camera bodies. I don't typically use this feature to reduce the power output of my on-camera flash, as I find it easy to confuse –1 on the flash with –1 on the whole exposure. Also, on some cameras, the in-camera flash exposure compensation is limited to ±2 stops. When you use the same feature on the flash itself, you can make adjustments up to ±3 stops.

Top left—No flash was used to capture this image. **Top right**—To add more light to the scene, I was able to "piggyback" two flash units inside of the "Doug Box" modifier. **Bottom**—Here is the final group portrait.

Left—Light meters are calibrated to 18 percent gray, so when I used the meter-recommended exposure for this shot, the result was a grayer rendering of what should have been a black shirt. **Right**—The meter averaged the light in the scene in this situation, too, so the recommended exposure made the shirt look gray.

Automatic vs. Manual. If you want to create a portrait of a subject standing in front of a striking sunset and you meter the sky, you will have an image in which the subject is silhouetted against the beautiful sky. Creating an image in which the sky and subject are both properly exposed will require that you add enough light to ensure that the light on the subject and the light on the background are balanced.

There are two ways to produce great results:

The Automatic Method. First, set your camera in the aperture priority mode. Select the evaluative (Canon) or matrix (Nikon) metering mode, and use your flash in E-TTL or I-TTL. I usually set the exposure compensation to –1 on the camera and no compensation on the flash.

When you are using this approach, you will want to check the image in the LCD to see if the metering method recommended an exposure that allowed you to record the image the way you envisioned. If it is not, you will need to increase or decrease the exposure of the background or the flash.

Our meters are designed to assume that the world is 18% gray. So, when the scene we are photographing is not middle gray, the camera will try to force the image to 18% gray. During a class, I was trying to explain how the meter tries to average everything to middle gray. I noticed two students were dressed perfectly to help out with a little demonstration.

Before taking the photos, I set the camera to the evaluative metering mode and ISO 100 and used the Program shooting mode (using the Tv or Av mode would produce the same results). When I pointed the camera

at the subject wearing the black top, the meter saw the black as gray without enough light on it and calculated an exposure that would render the overall scene as 18% gray. When I photographed the woman wearing the white top, the meter saw the predominance of white tones as gray with too much light on it and sought to underexpose the image to make the white gray. Look at the two images on the previous page. The lighting scenario was exactly the same in each image, but the recommended exposures made the exposure on the faces and backgrounds quite different.

If I had used my handheld exposure meter in the incident mode and measured the light falling on the subject, the meter would have read the exact same exposure on both subjects and given me the proper exposure to set on the camera. Both exposures would have been correct. Because I used the in-camera meter, I got two bad exposures!

I like to use the manual method—with both the camera and flash in manual mode—because I know that whatever I am metering will be recorded correctly.

The Manual Method. When you use your flash and camera in the manual mode, you can make educated decisions about your exposure that render your subjects the way they should be seen. Those automatic modes may be convenient, but they aren't very smart. That said, let's take another look at the results that can be achieved when working in manual mode.

The easiest way to wrap your head around adding flash when you are working in a scene where there is ambient light in the image is to approach it as if you were creating two different images (see page 87).

To create my photo, I first turned my attention to the sunset. I used the evaluative metering setting on my camera. In this metering mode, the camera analyzes the light and dark elements in the scene and, after making some fancy calculations, it comes up with a proper exposure.

If we want to make the sunset appear darker, deeper, and richer, we need to let less light strike the sensor.

As you know, if we want to make the sunset appear darker, deeper, and richer, we need to let less light strike the sensor. We can do this one of two ways: we can use a smaller aperture (e.g., if the exposure is $\frac{1}{30}$ at f/4, you could change the f-stop to f/5.6 or f/8) or a faster shutter speed (e.g., $\frac{1}{125}$ rather than $\frac{1}{60}$, but don't exceed the maximum sync speed). Since you could use either scenario to accomplish your objective, and the subject of this book is off-camera flash, let's use the shutter speed method.

Now I have my base exposure.

Having determined the right exposure for the sunset, I turned my attention to getting good results in the "second" image—the flash portion of the exposure.

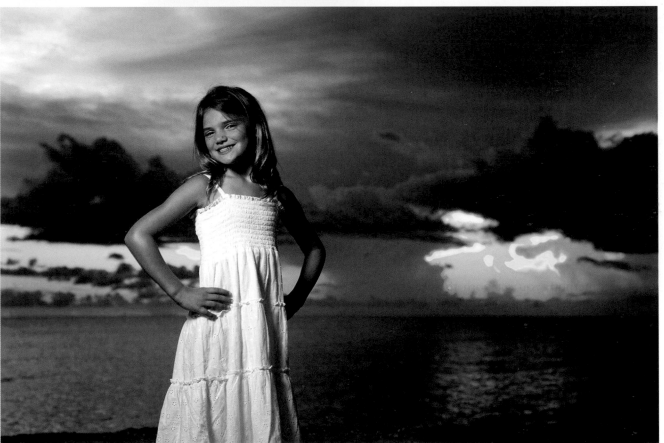

Top left—The sunset only. Meter the background using your in-camera meter set at –1 for a deeper, richer sunset. The exposure was f/5.6 at ¹⁄₆₀ and ISO 100. **Top right**—Bring the flash in at f/5.6 to match the background. **Bottom**—By thinking about your image as two separate exposures, you can make this process less confusing. When I suggest that you change the shutter speed, note that making the shutter speed one stop faster will darken the background.

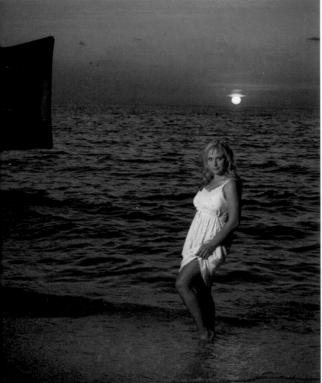

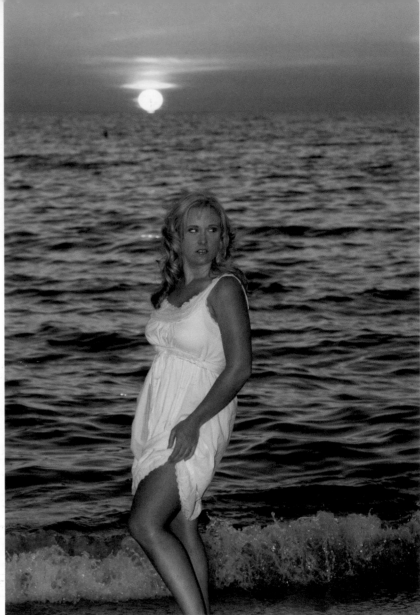

With this method, you set both the camera and flash in manual mode, then determine the exposure for the background using the in-camera meter. Next, bring in the flash at the same f-stop exposure and take the picture.

Here is the approach I used to create the image of the woman above:

1. I metered the background with my in-camera meter. In this scene, the reading was $\frac{1}{60}$ at f/8.
2. Next, I placed the meter in flash mode, set shutter speed to $\frac{1}{60}$, and read the flash.
3. I adjusted the power of the flash until it read the same as the reflected reading of the background—$\frac{1}{60}$ at f/8.
4. I set the camera at $\frac{1}{60}$ at f/8 and captured the image.

Top left—To create the final image, I first metered the background, shown here. **Bottom left**—This image was made using only on-camera flash. The result is a bland image. **Right**—Here is the shot made with off-camera flash. I like this shot, but if I wanted a darker background, all I would have to do is select a faster shutter speed (so long as it did not exceed the maximum sync speed).

When the sun is setting, you have to work quickly. With the camera and flash set to manual, the flash delivers exactly the same amount of light every time it fires, no matter what changes in the photograph, as long as the flash-to-subject distance remains the same. There is no need to re-meter, so shooting is fast and easy. In this session, I was able to shoot about fifty different images. If I had used the automatic mode, I would have had to adjust the exposure every time I changed the background.

There are a few things you should try to remember when shooting a scene like this. You may want to keep your subject posed against an expanse of unobstructed sky; remember that though you may be able to perceive buildings and trees in the background with your naked eye, they will be rendered in silhouette in the exposure unless you add flash. Using a low camera angle and a wide-angle lens may help you to isolate the

Here we have two images of the same subject and scene. In the first, off-camera flash illuminated the subject. In the second, the subject was left dark, creating a more graphic feel in the images. The exposure was f/14 at $^1/_{125}$ and ISO 200.

Left—In this image, we can see detail in the gate and fence behind the subject, but it is not as bright as the subject. **Right**—Can you imagine what this image would look like if it were made with on-camera flash? The light would be flat and boring, and the columns would be brighter than the bride because they are closer to the camera. The background would still be dramatic, but the lighting wouldn't be nearly as striking. To create this shot, I used a flash, housed in a softbox, in the 45°/45° position and shot into the shadow side of the subject. The exposure was f/5.6 at $\frac{1}{15}$ and ISO 800.

subject against the sky. That said, you can add visual interest and enhance the feeling of depth in your image by strategically including some darker-toned elements in your composition.

Secondary Subjects and Background Elements. There may be times when you want to create a portrait of a subject posed against a bright sky and want to include supporting background elements in the scene. In these cases, you can use falloff to your advantage.

Look at the image of the woman in the black dress. If I'd moved the light closer to the subject, the sign above the gate would be darker. Of course, if I'd moved the light closer, I'd have had to decrease the power of the flash so I wouldn't overexpose the subject. If I'd moved the flash farther from her and increased the light output to compensate for the loss of light, the background would be brighter. The light would be brightest on the subject and would fall off as it traveled toward the background.

You can use light falloff in the studio too. If you find that your studio backgrounds are too bright, try moving the fill light closer to the subject. The light will fall off, losing power before it strikes the background.

Overcast Days. Light on overcast days can be flat and dreary unless you use an off-camera flash to save the shot. With your flash, you can light the background softly, avoid hot spots, and make overcast lighting work for you. As an added benefit, the color temperature of the background will be cooler than the color temperature of the light on the subject, so the subject will really stand out.

Light on overcast days can be flat and dreary unless you use an off-camera flash to save the shot.

While in China for the Professional Photographers of America convention, PPA president Ron Nichols and I were out on a photo safari, looking for little fishing villages or something interesting to photograph. We drove for a few hours and seemed to be in the middle of nowhere. There was a jetty and a number of fisherman with poles. As we walked down to the beach, we saw a photographer and two wedding couples. I ran back to the car to grab my "Doug Box" modifier. With the help of our interpreter, I was able to capture some fun and completely unexpected bridal portraits.

While teaching at Waterton Park in Alberta, Canada, I came across a wonderful glacier-fed stream. The scene provided plenty of fill light, so I simply needed to add my main light to get the shot. I was working far from the subject and used a PocketWizard Plus II to trigger the main light. Because of the distance, I couldn't rely on an optical slave.

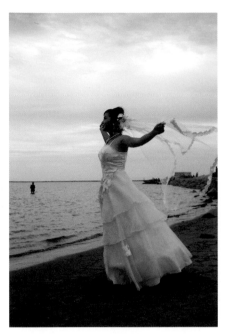

Left—Here is the image made with only existing light. As you can see, it would be tough to make a great image without adding flash. **Below**—To create this image, I first metered the scene. The exposure was f/11 at $^1/_{80}$ and ISO 200. I increased the shutter speed to $^1/_{160}$ by setting the in-camera meter to –1 so I could achieve a darker, more dramatic sky. Remember, when you add flash to illuminate the subject, changing to a faster shutter speed will darken the background. The final exposure was f/11 at $^1/_{160}$ and ISO 200.

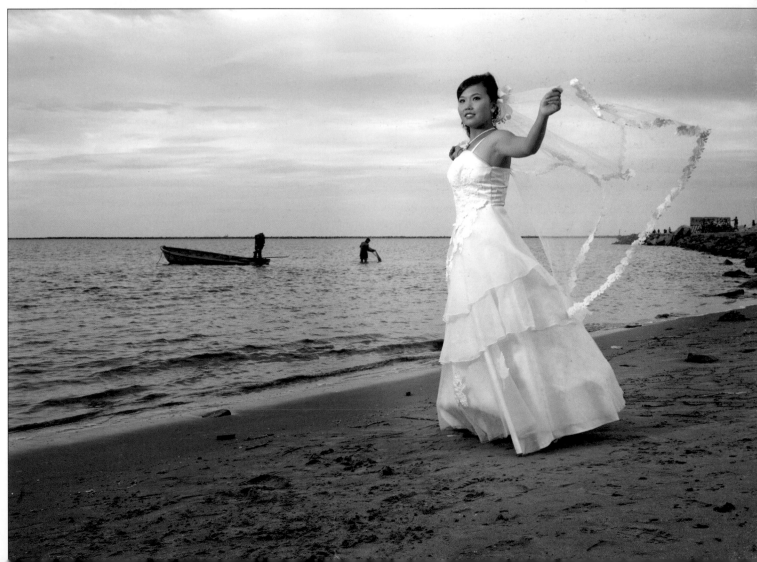

Left—There was plenty of ambient light in this scene to serve as fill. **Right**—I added a main light to light the subject and, in this case, the area behind the subject, in order to separate the subject from the background. The original exposure was $^1/_{125}$ at f/5 and ISO 200, and I wanted the final exposure to be $^2/_3$ more. The final exposure was $^1/_{125}$ at f/6.3 and ISO 200. Notice the placement of the light, at a 45º/45º angle from the far side of the subject's face.

I used a Canon 580 EX II (which had plenty of power), housed in the "Doug Box" modifier. I love using a softbox for these portraits. Look at how controlled the light is. It lit some of the background, which is perfect, as it made the subject stand out. If I had wanted less light on the background, I could have had my assistant turn the light more toward me.

The "Doug Box" modifier folds down to 7 inches in diameter and is lightweight, which really comes in handy when you need to climb down hills and over large rocks to light your shot, like my assistant did here.

Using Rim Light or Backlight. When you are photographing a backlit subject, you can use a reflector to add fill and decrease the contrast in the scene. However, if you've used a reflector in the past, you know what problems can result—you'll need an assistant to hold the modifier, it's hard to control the amount of light that falls on the subjects, and the subjects may squint. Also, some photographers don't know how to hold a reflector to achieve flattering results. They hold the reflector too low, which causes the light to come from a low angle. As a main light, I like for the flash to come from the 45°/45° position. To get the light in this position and produce catchlights in the 10 and 2 o'clock positions, you would need to hold the reflector above your head.

When you use a flash to add light to the shadow areas (the front of the subjects), these problems are eliminated. Your trusty light stand is your assistant (and they never complain), you can change the light in ⅓-

This pair of images shows the improvement that adding flash can make in your backlit images. The original image, made without flash, is on the left. The final image is shown on the right The exposure was f/5 at ¹⁄₅₀ and ISO 200.

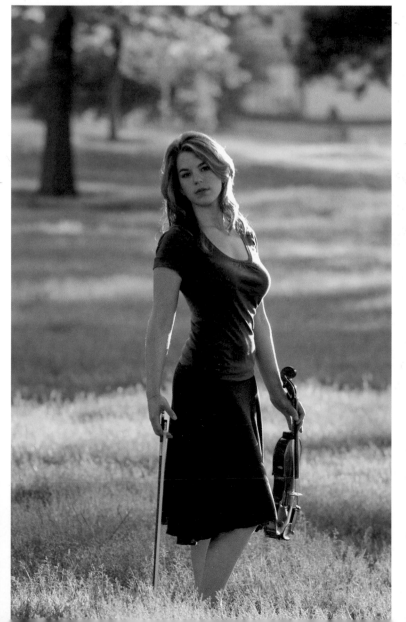
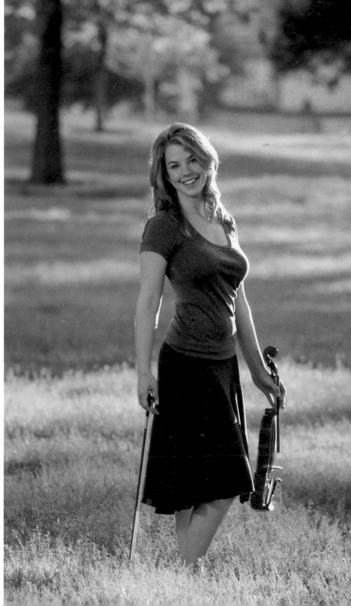

Top left—Though the sky in this scene was beautiful, the natural light didn't light the subjects properly for a portrait. This image was made without flash. The exposure was f/9 at ¹⁄₆₀ and ISO 100. **Top right**—This image was made with flash. I used the same exposure, but notice how dark the shadow side of the girls' faces are. **Bottom**—For the final image, I used on-camera flash set at –2 in the E-TTL mode as a fill light to lighten the shadow side of the girls.

Using flash can prevent problems inherent in adding reflected light to reduce contrast in backlit scenes.

stop increments, and because you will introduce the flash so that the subject is looking away from the light rather than into a bright reflector, there is no squinting.

I have created a pocket guide for using your off-camera flash. You can download it, print it, and keep it handy. This quick guide explains the basic settings for on and off-camera flash operation. Download it free at www.dougbox.com/shop/.

6. MIXED LIGHTING

COLOR CONVERSION GELS

Every light source, natural or artificial, has a specific color temperature, measured in Kelvin degrees. Daylight and flash, for instance, have a color temperature of about 5500K, while incandescent light measures about 3200K. The lower the temperature of the source, the "warmer" the light. The higher the color temperature, the "cooler" the light.

When you're working in the studio, you have complete control over your lighting. However, when you're shooting on location, you will encounter many lighting variables. When you're faced with working with lights of different color temperatures, you have a powerful tool at your disposal: gels. These gelatin sheets can be used to modify your light source, changing the color temperature of your flash. You cannot gel the ambient light, so you must gel your on or off-camera flash to match the color temperature of the ambient light.

Here are two images taken on a cruise ship. It was nighttime, so the incandescent lightbulbs provided the only light in the scene (top). To capture the final image (bottom), I determined the exposure, placed a conversion filter on my flash, and changed the camera's white balance preset to incandescent. That was it.

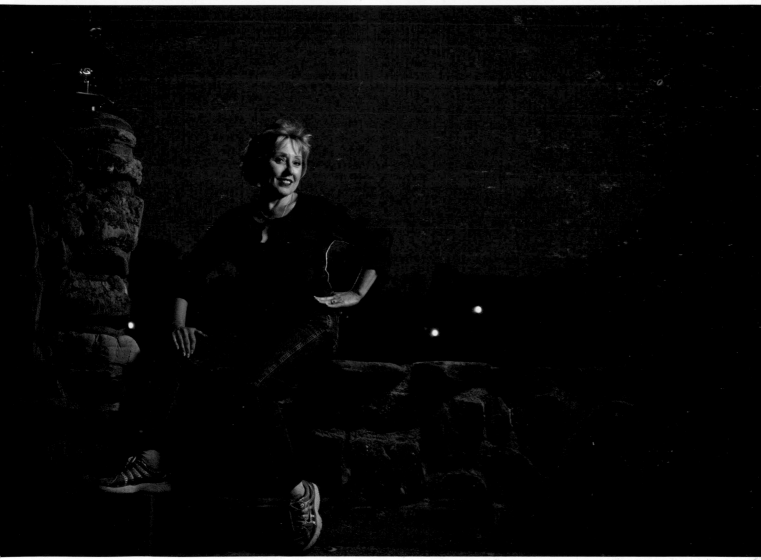

Top left—I photographed this image using an off-camera flash (5500K) modified with a color conversion gel to bring the flash temperature to 3200K. I also set the camera's white balance preset to incandescent in order to produce neutral skin tones on the subject. However, the rest of the image has a blue color cast because the light is 5500K or higher. In addition, the light is flat and boring. The exposure was f/4 at $^1\!/_6$ and ISO 200. The flash metered at f/4. **Top right**—Here is the setup shot for the final image. The softbox was placed at the 45°/45° position. It was positioned perpendicular to the ground, so that the face of the box was parallel to the subject's face. If you take a close look the final image, you can see that this rendered the face perfectly lit, and the light gently fell off so the subject's shirt and pants—and even the rock wall—did not appear overlit. A small Morris Midi light with a warm gel was used below and behind the subject as a rim light. **Bottom**—Here is the final image. Selecting a faster shutter speed ($^1\!/_{60}$) rendered the background 3.5 stops underexposed, rendering the sky darker and more dramatic.

Each of the images in this series was made using the E-TTL mode on the on-camera flash, and each has a different contrast range, yet the images were captured almost as quickly as the flash recycled. Note that the subject's back, which was initially quite dark, became lighter with each exposure change. The exposure of the subject's face was consistent throughout all of the images because the off-camera flash was used in manual mode. The camera was also used in the manual mode. As the man's back becomes lighter, it also becomes more blue because of the color cast that an ungelled on-camera flash added when lighting the back of the subject. What a difference using gelled flash can make! The flash exposure compensation for the final image was set to −2.

I keep a pack of gels in my
case. There are several great
gel kits available online at
www.honlphoto.com,
www.strobist.com, and
www.lumiquest.com. You can
also buy sheets of the gels
from most camera stores.
Alternatively, if you can find a
sample pack of Rosco or Lee
filters, you can simply tape
the small samples to the front
of your flash.

CASE STUDY: GELS AND EXPOSURE COMPENSATION

The images of the biker on the facing page were made in a challenging lighting situation. Let's take a look at how I was able to make a successful image using gels and flash exposure compensation.

Here's the scenario: The light in this scene came from streetlights—sodium vapor lights with a color temperature of roughly 2750K. I didn't have the proper gel to convert my flash to 2750K, so I used a color conversion gel to produce an incandescent color balance, which is approximately 3200K. As you can see, the background is a little warm and the man's back is too dark. The color isn't perfect, but I like the way it looks. The exposure was f/4 at 0.5 second and ISO 200. In the first image, the on-camera flash was off.

To create the second, third, and fourth and fifth images in the series, I changed the flash exposure compensation on my ungelled on-camera flash to –3, –2, and –1, and 0 respectively. I used the flash compensation setting on the back of the flash rather than making the change via my camera. It is faster and allows for a –3 exposure, versus the camera's maximum setting of –2. Each of the images in this series was made using the E-TTL mode on the on-camera flash, and each has a different contrast range, yet the images were captured almost as quickly as the flash recycled. The exposure of the subject's face was consistent throughout all of the images because the off-camera flash was used in manual mode. The camera was also used in the manual mode. See the caption for additional details.

USING GELS FOR CREATIVE EFFECT

Sure, gels come in handy when you need to convert your flash units to match the color of the ambient light in the scene, but you can also use gels to create more interesting effects. There are some times when you may want to add strong color to a background or to an overall scene to create a more diverse array of image looks or moods. I keep a pack of gels in my camera bag at all times. I am surprised at how often I grab a little piece of color magic.

The images on the next page show how you can use gels to create a wide variety of portrait looks for your clients. By adding creative color to your images, you can add mood and character to your portrait offerings, which can lead to bigger sales.

Left—This image was made with an ungelled flash and a softbox. Right—Here, you can see the effect that was achieved when a purple gel was added to the kicker light (a flash) positioned behind the subject. I like both photographs, but the one made with the gelled flash seems to have more depth and appeal.

Left and center—To create these two images, I used small Morris slaves with gels to color the black corrugated tin background. Right—To create the final image, I simply pointed the lights toward the camera, and they became an interesting part of the overall composition.

USING FLASH WITH CONTINUOUS LIGHT

Flash is my preferred lighting tool for the majority of my portrait work. However, there are times when I use a continuous light source. Let's take a look at a few scenarios in which both types of lighting units were used, so that you can learn to anticipate the challenges you may encounter when shooting this type of session.

Left—This setup shot shows the use of a black flag to keep light from hitting the subject's arm. **Right**—This image was made using continuous light and flash. The main light was a Westcott Spiderlite, a daylight-balanced continuous light source. A flash housed in a "Doug Box" modifier served as the hair/kicker light. The exposure was f/4 at $\frac{1}{8}$ second and ISO 100. When you use constant lighting, you can easily see the lighting effect that is being created. However, because the lights are not as powerful as flash, you will usually need to use a high ISO or a slow shutter speed to produce an acceptable exposure.

Top and bottom left—Here, the main light was a flash housed in a "Doug Box" modifier. The hair light was a Westcott continuous lightbulb in a "Doug Box" modifier. The single Westcott bulb obviously produced less light than the five-bulb Spiderlite, so I used an exposure of f/6.3 at $^1/_{10}$ and ISO 800. The color temperature of the light the bulb produces is similar to daylight. *(Note:* To use such a bulb in the "Doug Box," you will need to purchase an umbrella socket bracket with $^5/_8$-inch stand mount, which is available at www.themorriscompany.com.) Note how beautifully the light falls off from the face to the body. This is due to the great design of the softbox, because the face of the box was parallel to the subject, and the box was used at the 45º/45º position. The exposure in these images was identical. The difference in the results is due to moving the subject farther from the background. **Above**—This image shows the setup used to create the images on the left.

7. KICKER LIGHTS

A kicker light is used to add roundness and dimension in your portraits. It is generally placed opposite the main light, behind and to the side of the subject. To determine proper placement, draw an imaginary line from the main light through the subject. The light should be

Right—The original image, made without flash or a kicker light. As you can see, the background was brighter than the light on the subject, so I needed to add flash at the same exposure as the background. This shot was made at a focal length of 70mm. The exposure was $\frac{1}{125}$ at f/7.1 and ISO 200.

For this series, I set the "Doug Box" modifier at camera left, then I set the kicker light opposite the main. The kicker was not used in the image on the left. The center shot was made with the kicker light. In the final image, I used a warming gel to add a new dimension to the photograph. I used a focal length of 200mm to capture these images.

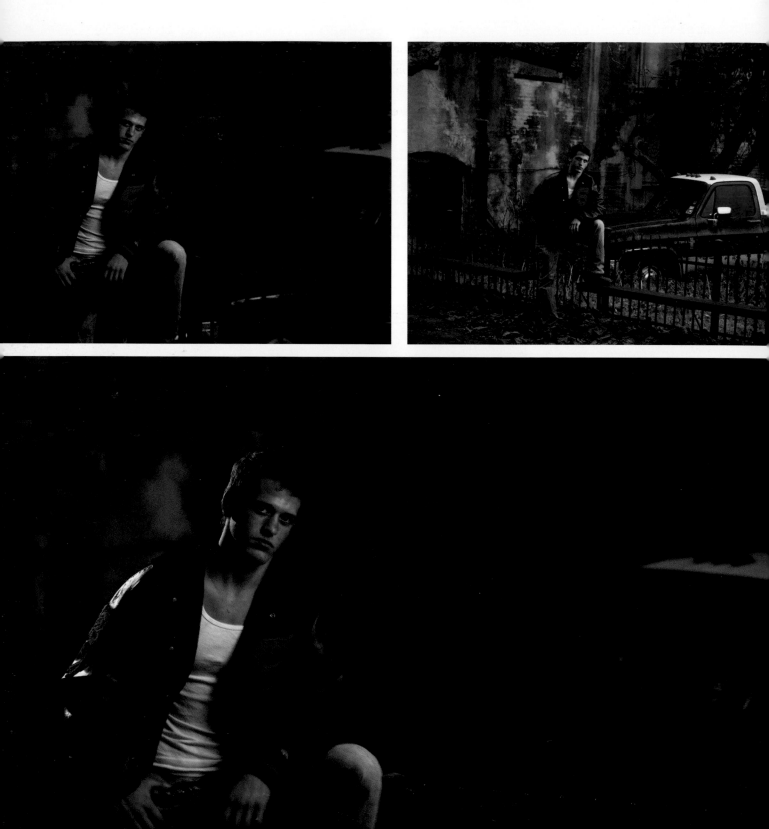

The images of the young man were done late in the evening. In fact, a streetlight came on while we were making this image. You can see where the streetlight added some shadows and lent an interesting color to the image. The color may not be perfect, but it looks cool. The kicker light added a nice touch.

placed on this axis as a starting point. You will need to adjust the position as necessary to keep light from hitting the subject's nose.

I use kicker lights in the studio and outdoors. I feel that they can help to further differentiate our images from the competition and, certainly, from the shots made by amateurs.

My subject in these images was the head of the reservation department at the hotel we were staying in. You can see the simple setup of the main and kicker lights (top-left image). This is an ambient fill situation. I used an assistant to hold the kicker light. Of course, a light stand would also work. The exposure in the top-right image was f/4 at $1/13$ and ISO 200. In the bottom-right image, I used a slow speed to pick up light from the incandescent bulb for more depth and realism. A faster shutter speed would have caused the background to go dark. Note that using a kicker light can also help to separate the subject from the background (bottom-right image).

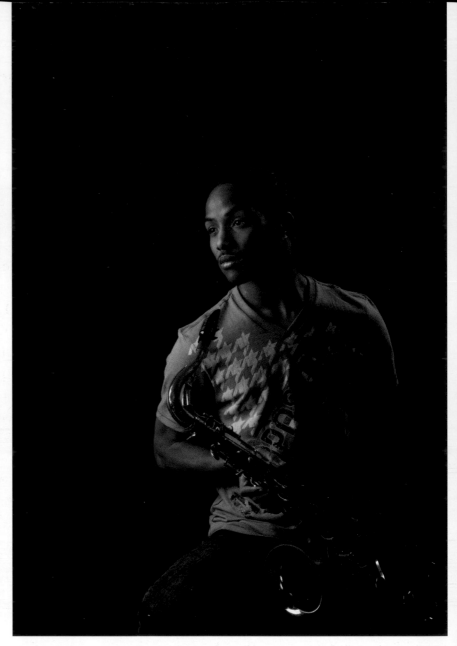

Top left—I used a 4x6-foot softbox with a ProPhoto studio strobe as a main light source to light this image of a musician. **Bottom left**—I used this setup to shoot the image again, this time with a kicker light. **Right**—In this image, I added a kicker light to make the image look more professional and create tonal separation from the background.

USING A SHOE-MOUNTED FLASH AS A KICKER LIGHT

I keep my "Doug Box" modifier set up all the time. That way, if I go outside to do any kind of session, I just grab it and go. Since it is set up, I figure I might as well use it. So, I often use it as a kicker light when I am working in the studio.

8. NIGHT AND STREET SHOTS

There is something magical about shooting evening street scenes. I typically use the exposure calculator to get my starting exposure, then I look at the meter reading and I sneak a peak at the LCD screen to review my base exposure. Next, I add enough flash to ensure that the subject is as bright as the background.

Noise is the natural enemy of night and street shots. Choose a low ISO to keep the noise down. If you do get noise, consider trying NIK Software's Dfine 2.0 (www.niksoftware.com) to reduce contrast noise (luminance) and color noise (chrominance).

Let's take a look at a trio of location portraits made at night, against an architectural backdrop.

The first photo is an interesting silhouette, followed by a nice off-camera flash shot. For the third image, I added a new element, zoom. I took six or seven images and experimented with zoom rates and starting and stopping points. The camera was set to front-curtain sync, and I zoomed from 24mm to 105mm.

Top left—Here is the scene before flash was added. The meter reading was $\frac{1}{60}$ second at f/4 and ISO 200. **Top right**— I added flash to light the subject. The exposure was 0.6 second at f/7.1 and ISO 200. This exposure is equivalent to the first exposure. I used the exposure calculator to find the best exposure for the scene. **Bottom**—I used front-curtain sync and zoomed my lens from 24mm to 105mm to produce the effect shown in this image.

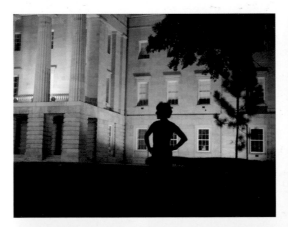

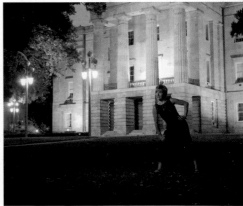

Below, we have another series of night shots. The images and captions show how I approached the session.

Finally, let's look at a night shot that was illuminated by existing light (streetlights and holiday lights), an on-camera flash, and an off-camera flash. The following photos and captions illustrate the lighting and exposure decisions I made for this subject and scene.

 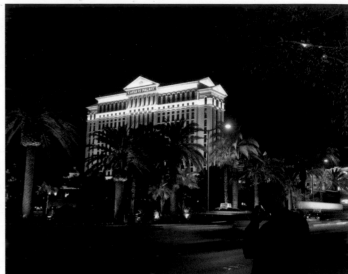

Left—First, I composed the image and determined the exposure for the "first image," the background. (Again, it's helpful to approach a lighting scenario in which the background is brighter than the subject as though you were shooting two different images.) The setting metered 0.4 seconds at f/6.3 and ISO 800. I used the evaluative metering mode because of the nice mix of dark areas and lights. **Right**—Next, I added the subject.

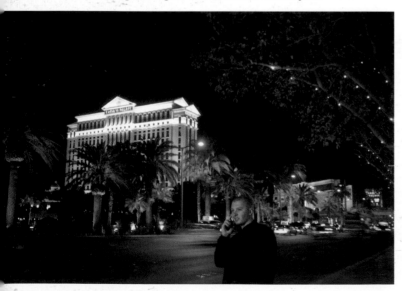 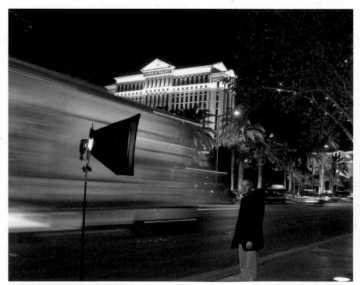

Left—I positioned my off-camera flash to light the front of the subject to match the background exposure to produce the final image. **Right**—I saw a bus coming down the road and decided to take advantage of the slow shutter speed to capture its motion in the image. Note that the image also shows the placement of the softbox.

Top left—This image shows the subject and scene illuminated by only Christmas lights and a streetlight. **Top right**—Here we see the effect created by introducing an on-camera flash. The result is anything but polished. However, the flash would function well as a fill light. I used the flash in E-TTL mode and set it to –2. **Bottom**—Finally, I added the off-camera flash at the same exposure as the background exposure—¹/₅ second at f/4.5 and ISO 400. This flash was the main light. The on-camera flash filled in the shadow side of the face and brought out detail in the subject's clothing.

9. USING TWO LIGHTS AT WEDDINGS

Using two lights at a wedding is a topic that is almost worthy of its own book (see my *Professional Secrets of Wedding Photography*, 2nd ed.). As you may find yourself shooting in a scenario that can benefit from the use of two lights, though, I will present some basics here.

I've used twin lighting without an assistant for over thirty-four years. I'll show you how to get the job done without moving the second light around too much.

TWIN LIGHTING BASICS

Using two flash units—one as a main light and one as fill—will allow you to capture key moments with more detail than you can record with one light. With a second light, you'll be able to record detail in the bride's gown, show texture on the cake, and throw light on numerous faces when photographing large groups—with little extra effort on your part.

Left—Twin lighting was used to create this image. The off-camera flash was used to light the bridesmaids, and on-camera flash illuminated the bride. **Right**—In this portrait we have used several of the techniques described in this book. Off-camera flash was used as the main light. On-camera flash provided the fill light. I metered the background to determine the base exposure—f/5.6 at $^1/_{13}$ and ISO 400—then brought the flash to that exposure. Notice the warmth in the background. I used the flash white balance preset, which caused the incandescent lights to be recorded warm.

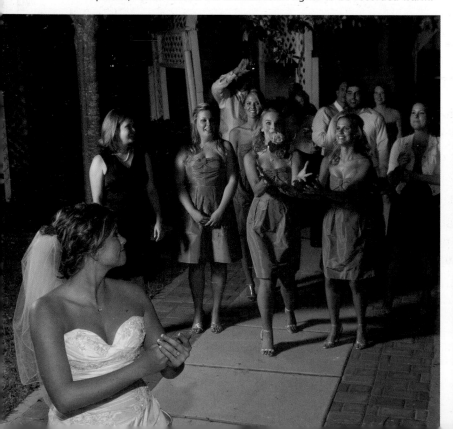
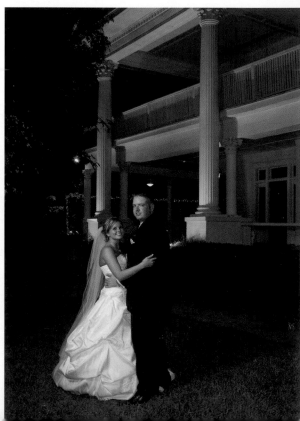

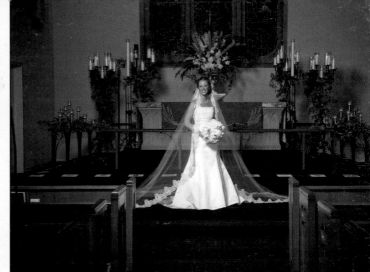

Top left and right—As seen in the left-hand image, I used an off-camera flash, housed in a softbox, as the main light for this image. On-camera flash, set at –2, provided fill light. I used the same setup to photograph the bride alone. **Bottom**—To create this image, an off-camera flash was used as the main light. I metered the main light and set my camera accordingly. The on-camera flash, set –2 in the E-TTL mode, filled in some of the shadows, allowing me to show important detail.

At a wedding and reception, you've got to work quickly and confidently to capture key moments and spontaneous activity. When I'm shooting, I do my best not to change the power of the flash. I don't want to risk forgetting to change it back. I set it at 100 watt-seconds and move it closer to or farther from the subjects to increase or decrease the intensity of the light striking them. Then I use the meter to determine the exposure. It pays to eliminate as many variables as possible to simplify your shoot. When taking wedding photos, your shooting has got to come

When I am photographing groups, my on-camera flash is my main light. The off-camera flash is used only as an accent light. This setup allows me to capture more texture in the image and avoid casting shadows on the back row. I set the on-camera flash to 0 in the E-TTL mode. The off-camera flash is set to 100 watt-seconds and is placed about 20 feet from the group. This gives me a reading between f/2.8 and f/4. I set the camera at f/5.6.

Left—Two flash units are better than one. Compare the results of these two images. On the left, we have an image made with on-camera flash only. The exposure was 1/20 at f/5.6 and ISO 400, and the flash was set to 0. The camera was set to the flash white balance preset. **Right**—To create this image, all I did was add the off-camera flash, which was set at 100 watt-seconds. This produced a reading of f/3.6 at the group (1 1/3 stops less than main light). If you look closely, you can see that everything has a little more detail, the colors are a little cleaner, and there is a little direction to the light. It is subtle, but there is definitely a difference.

easily. Making lighting and exposure decisions should be second nature.

Note: Never try out a new technique on a paying client—especially at a once-in-a-lifetime event like a wedding. If you must try it, take just one shot in a particular situation, then go back to your regular shots. You don't want to create bad images of key moments on a bride's wedding day by experimenting with a new technique.

When I am using twin lighting my camera and off-camera flash are both set to manual mode and the on-camera flash is set to E-TTL mode. I have the control I need to create images with different contrast ranges, yet the approach is simple.

Let's take a look at a series of images made using the twin-lighting method. I was able to capture five images, each with a different contrast range, as fast as the flash would recycle. The first shot was made using only off-camera flash, and the next four images were shot with the on-camera flash added and set to –3, –2, –1, and 0. To make these

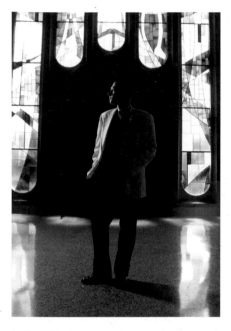 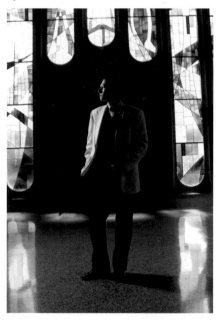

Left—This image was created using only off-camera flash. I metered the stained glass. The exposure was f/5.6 at ¹/₁₆₀ and ISO 100. I moved my flash until it read f/5.6. **Center**—For this image, I used off-camera flash and added my on-camera flash at –3. The exposure was f/5.6 at ¹/₁₆₀ and ISO 100. **Right**—For this image, I used off-camera flash and added my on-camera flash at –2. The exposure was f/5.6 at ¹/₁₆₀ and ISO 100.

Left—This shot was made with an off-camera flash and an on-camera flash, which was set to –1. The exposure was f/5.6 at ¹/₁₆₀ and ISO 100. **Right**—Here, I used off-camera flash and on-camera flash, set to 0. The exposure was f/5.6 at ¹/₁₆₀ and ISO 100. My default setting for using my on-camera flash as a fill light is –2.

In this image, the groom and his mom are closer to the camera than the bride and her dad. If I had used just an on-camera flash, I would not have been able to properly expose both couples. The front couple would be exposed properly and the back couple would have been dark, or the back couple would have looked good but some of the tones in the front couple would have been blown out.

To save the shot, I set an off-camera flash near the DJ's speaker and aimed it toward the crowd. With this light in place, the center of the dance floor metered about f/8, and I was able to get a good exposure for both couples. I used a fast shutter speed of $\frac{1}{60}$ to make the background go dark, since the location featured low ceilings, panelled walls, and folding chairs. The on-camera flash was set to 0, and the camera was set to f/8.

THE GEAR BAG

When shooting weddings, there are a number of tools that I find indispensable:

o Canon 5D Mark II
o 70–200mm f/4 lens
o 24–105mm f/4 lens
o Profoto Acute B 600 (with built-in PocketWizard or Lumidyne)
o Canon 580 EX II flash
o Canon flash extension cord
o Custom Bracket flash bracket
o PocketWizard Plus II
o "Doug Box" modifier
o Manfroto 458-B tripod
o 13-foot light stand
o Gitzo G-1376M head
o Sekonic L-358 light meter
o Backup equipment

changes, I simply pushed the small button inside the dial of my Canon 580 EX II flash.

When the flash compensation number blinked, I turned the dial three clicks counterclockwise to go down one stop, make the image, then repeat. I did not need to re-meter since the off-camera flash was set to manual. The flash gave me the precise amount of light each time.

When I am photographing people dancing, I try to keep my camera at 90 degrees to the off-camera flash, which is placed near the band or DJ. This way, I get a directional quality from the light.

I shoot all of these images from a tripod to prevent blurriness in the image. It also gives me a place to rest the camera, instead of around my neck, makes me look more professional, and allows me to better interact with my subjects.

MY PERSONAL APPROACH TO SHOOTING WEDDINGS

I realize that there are as many ways to photograph a wedding as there are photographers, so I am just going to show you how I do it. I want great photographs for my couples, a fairly simple system, and the ability to accomplish all of this with a minimum amount of equipment.

Here is what I do: Upon arriving at the location, I walk around and look for places to photograph. I take meter readings and photograph my target on the back of the exposure calculator in the different lighting conditions.

I typically photograph the bride and bridesmaids first. If I will be photographing them in the dressing room, I look to see what the lighting will be, for instance, whether I will need to use the side wall bounce method or if there is room to use off-camera flash. I do some candid and photojournalistic images at every wedding—some without flash—but as this book is about flash, I'm going to limit this discussion to flash-lit shots.

Next, I photograph the guys. Many times when things get down to the wire, your plans for great lighting go out the door and you have to shoot for a good expression. When time is limited, I try to pose the subjects under a covered porch or some trees to block the top light. In some situations, I simply use my on-camera flash, set at –2, to fill in the shadows that top light can create.

Next, I capture all of the ceremony photos, without flash, then head outside to photograph the couple greeting their guests.

The last task in photographing at the ceremony site requires having the couple and wedding party return to the altar for some twin lighting

Top left—This image was made with only on-camera flash. It's not a bad photo. It shows lots of fun and excitement, but it lacks roundness and depth. Also notice there is a warm color cast on the subjects in the background. This was due to using a slow shutter speed. I chose exposure settings of f/4 at $^1/_{13}$ and ISO 400 to show the custom lighting in the background. Due to the slow shutter speed, you can see a little motion blur on some of the subjects, but I think it adds to the fun feeling of the image. **Bottom left**—This image shows the placement of the second light. Of course, I crop it out for the final photo. **Right**—This shot shows the effect of lighting with two flash units. You can see a roundness and dimensionality in the subjects, there is direction to light, and the color is cleaner. I waited until the groom's face was in perfect position for profile lighting when I took the photograph.

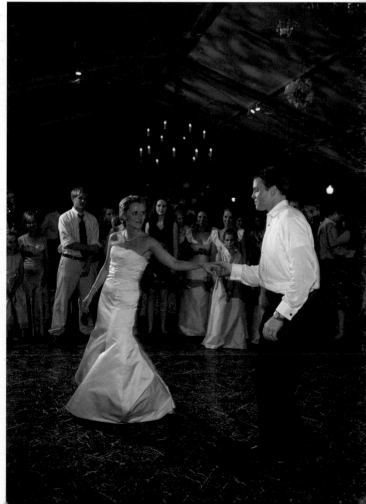

Left—Keep an eye out for opportunities to photograph some of the special items the bride and groom selected for their wedding. Right—With careful lighting, you can avoid creating hot spots on the cake and show it to best effect.

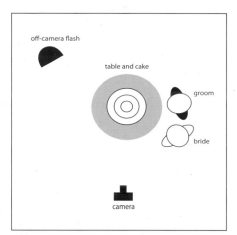

Left—In this shot, overhead light was blocked by the tent under which the couple was posed. Off-camera flash was added from behind the subject position at camera left. The exposure was f/22 at $\frac{1}{80}$ and ISO 400. The setup is show in the diagram.

shots. I photograph the group and minister first, to get them out of the way. (You score a lot of points here.) As I mentioned earlier, I use my on-camera flash as my main light when I am photographing large groups. I set the flash compensation to 0. That way, the E-TTL will give me good exposure automatically. I usually set the f-stop to f/5.6. That provides plenty of depth of field. I back up so I can use a 50mm or longer focal length setting on my lens. This prevents distortion issues, especially with the head size, and it helps to even out my lighting from front to back.

I use a shutter speed of around $^1/_{15}$, depending on the brightness in the church. The camera, of course, is on a tripod. If I am working alongside a videographer who is using bright lights, I ask him to turn them off or I use a higher shutter speed so the lights won't cause color shifts. My off-camera flash is set at camera left, about 20 to 30 feet from the group and 6 to 10 feet from the camera. I position the light so it is feathered to the right and meters between f/2.8 and f/4 (1 to 2 stops below the main light). These are my go-to settings for group shots. I alter my distance from the subjects depending on the group's size and zoom to 105mm when possible.

I keep the light in the same position for the group shots and never need to re-meter.

I move the light onto the altar to photograph the bride and groom in profile. When I meter the flash, it is usually between f/8 and f/11, and I set that aperture on the camera. I use the same shutter speed I employed when I photographed the group shots. The off-camera flash is the main light and the on-camera flash, set to –2, is the fill light. Note that the –2 setting is my starting point. If I want more contrast, I go to –3. If I need less contrast, I select the –1 setting.

Next, I turn the bride to face the camera. I put the off-camera flash about 10 to 12 feet from her in the 45 degree position, meter the light, set that aperture on the camera (usually f/8 to f/11), and add the on-camera flash at –2.

This shot was a little tricky. The lights on the painting were brighter than the lights on the stairs. First, I metered the light on the painting—f/4.5 at $^1/_{20}$ and ISO 400. This was my base exposure. Next, I turned the flash up until it meters f/4.5. I chose to place the flash at camera right so as not to "overflash" the front of the staircase.

At the reception, I position the off-camera flash near the band or DJ. At about 20 to 25 feet away on the dance floor, it will read about f/8. I set the camera on f/8 and keep it at about a 90 degree angle from the flash. I move it a few times for the cake cutting and bouquet throwing and such.

When I photograph a cake, I approach it like a commercial shoot. The off-camera flash, positioned about 120 to 140 degrees from the camera, is the main light. The on-camera flash, set to –2 or –3, is the fill light. With this setup, you get great detail and no blown-out areas. When the couple steps up, the lighting setup remains unchanged, and it yields perfect profile lighting on the bride. See the diagram on page 116.

Left—Careful subject placement and placing the flash at the 45°/45° position helped to create an interesting image. Of course, I crop out the flash in the final image. **Bottom left**—Here is the image made with only ambient light. **Bottom right**—In this image, I added the on-camera flash at –3. The flash was positioned behind the wall to the left and in front of the bride. I only needed a small amount of light on the shadow side. When I use on-camera flash as a fill light, I do not use a modifier. It's just not necessary.

10. LIGHTING GROUPS WITH FLASH

I am often asked how big of a group can be lit using off-camera flash. That's a tough question because a number of variables come into play, including the ISO and f-stop you select, your flash output, the architecture of the room (low ceilings versus high ceilings, etc.), how spread out the group is, how much available light there is, etc.

I've included some photos of fairly large groups in this chapter. Each image was lit using a shoe-mounted flash housed in a "Doug Box" modifier. For two of the images, I removed the front cover of the softbox. As you can see, a small flash can light a pretty good-sized group.

SELECTING THE RIGHT LENS

Most new photographers, when presented with the opportunity to photograph a large group, will choose a wide-angle lens. They think that this approach will allow them to capture the whole group from a closer distance so their battery-powered flash won't run out of power. Unfortu-

The exposure for this image was $^1/_{200}$ second at f/10 and ISO 100. I captured the image with a 24mm lens. The corners of the image are dark because I added a vignette in Camera Raw.

Facing page—(Top) Find the best light and make it better. For this shot, I positioned off-camera flash on the right, where the open sky was. (Bottom) Note the evenness of the light from front to back and left to right. The was done with the face of the softbox removed.

nately, the lens "sees" the group as more spread out when using a wider lens and shooting from close up, and the heads of the subjects in the front of the group appear much larger than the heads of those in the back. This doesn't allow for the best presentation of the subjects. Increasing the distance from your subjects and switching to a longer lens will help to ensure a more correct head size in the image.

There is another benefit to working farther from the group. If you are using on-camera flash, backing up will make the light more even from the front row to the back row.

Left—The exposure for this image was $1/100$ at f/5.6 and ISO 200. I used the 32mm setting on the lens. Note how shooting close to the group with a wide-angle lens made the head sizes of the back row of subjects appear much smaller than they seem to be in the front row. **Right**—By shooting and lighting the group from a longer distance and selecting an 85mm lens, I was able to correct the head-size discrepancy. As you can see, the longer working distance helped to ensure more even lighting across all members of the group as well.

11. BEYOND PORTRAITURE

NATURE AND FLOWER PHOTOGRAPHY

Flower portraits can be fun. I light flowers just like I light portraits—with a main light, kicker light, and background light. I shot these images with three Canon 580 EX II flashes.

In the photos of the orchid, you can see what happens when you let too much ambient light into your image. The top photo was taken at f/6.3 at $\frac{1}{125}$. The bottom image was shot at f/6.3 at $\frac{1}{20}$. Note how the slower shutter speed allowed the fluorescent room light to cause the color to shift. The faster shutter speed prevented the contamination.

Top and bottom left—To light this image, I set my flash inside of a white, shoot-through umbrella, which was placed on a stand. I used the flash in the slave mode and used a Canon ST-E2 transmitter to control the flash. It was all done automatically, and the results look good to me. Automatic flash systems work best when the subject and background are similar in tone. **Top and bottom right**—Here you can see the effect of letting too much ambient light into your image. The exposure for the top image was f/6.3 at $\frac{1}{125}$. The lower photo was taken at f/6.3 at $\frac{1}{20}$. You can see how the slower shutter speed allowed the fluorescent light in the room to cause the color to shift. The faster shutter speed stopped the contamination.

Above—When photographing a knife, whatever the blade "sees" will be reflected and appear in the image. This scrim allowed me to create the ideal shooting environment to show the shape of the knife. **Top right**—Look closely at this photograph of the knife. See the gentle falloff of light on the blade? This particular blade is called "Hollow Ground." It has a concave shape. To illustrate the curve of the blade, I had to position the blade so that it "saw" the area of scrim where the tones transition from white to gray. Sometimes you have to tilt the blade front to back to find the ideal position. I used only one light for this shot. **Bottom right**—I added another piece of Plexiglas and a small flash to light the bottom of the handle for this second shot.

CUSTOM KNIFE PHOTOGRAPHY

The key to making good knife and gun photographs is having a large light source. Most people try to photograph a knife with their on-camera flash. If you have tried this, you know that it just won't work. The blade of a knife is reflective and, therefore, whatever is reflected in the blade (often the ceiling) will appear in the image. Likewise, if the room in which you are working is dark, the knife blade will appear dark because the dark ceiling will be reflected.

So how do you solve this problem? You need to spread out your light by using something large and uniform in texture for your blade to "see."

There are several options you can use: you can shine the light through a milk-white piece of acrylic or Plexiglas (it has a perfectly smooth white surface) or you can suspend acetate (a thin sheet of frosted plastic) for use as a permanent scrim. You can also use a piece of white nylon stretched tight over a PVC pipe frame. The most important thing is that it is flat or stretched tight so it does not have any wrinkles.

If you are interested in more information on knife and gun photography, visit www.dougbox.com/shop/. I offer a course on the subject.

SMALL PRODUCT PHOTOGRAPHY

When photographing products, it is very important to ensure that the small details are visible. Let's look at some photo examples that show how this can best be achieved.

To create this series of images, I used the same three-sided homemade acrylic light box I used to create the knife photographs. The only difference is where the light was coming from. I used my on-camera flash, pointed at the ceiling, to trigger the other flashes via optical sensors. (*Note:* I could have just as easily used any of the other methods to trigger the flashes.)

Left—This image shows the placement of the background flash, which was positioned on top of the Dr. Pepper can. **Right**—Here you can see the setup. I used my home made acrylic light box with two flashes, a Canon 580 EX II and a Morris slave. The on-camera flash was only used to trigger the other units.

Left—Here is what the subject looked like illuminated by only on-camera flash. **Center**—I used one flash from the right to create this image. **Right**—Two flashes were used here—one on the left and one on the right.

Right—I used one additional flash to create this image. Now there was one flash on the left, one on the right, and one behind the background. See how the background is brighter here than it was in the previous image.

INDEX

OTHER BOOKS FROM
Amherst Media®

DOUG BOX'S GUIDE TO

Posing for Portrait Photographers

Based on Doug Box's popular workshops for professional photographers, this visually intensive book allows you to quickly master the skills needed to pose men, women, children, and groups. *$34.95 list, 8.5x11, 128p, 200 color images, index, order no. 1878.*

WES KRONINGER'S

Lighting Design Techniques

FOR DIGITAL PHOTOGRAPHERS

Design portrait lighting setups that blur the lines between fashion, editorial, and traditional portrait styles. *$34.95 list, 8.5x11, 128p, 80 color images, 60 diagrams, index, order no. 1930.*

CHRISTOPHER GREY'S

Studio Lighting Techniques for Photography

With these strategies—and some practice—you'll approach your sessions with confidence! *$34.95 list, 8.5x11, 128p, 320 color images, index, order no. 1892.*

500 Poses for Photographing Women

Michelle Perkins

A vast assortment of inspiring images, from head-and-shoulders to full-length portraits, and classic to contemporary styles—perfect for when you need a little shot of inspiration to create a new pose. *$34.95 list, 8.5x11, 128p, 500 color images, order no. 1879.*

Advanced Wedding Photojournalism

Tracy Dorr

Tracy Dorr charts a path to a new creative mindset, showing you how to get better tuned in to a wedding's events and participants so you're poised to capture outstanding, emotional images. *$34.95 list, 8.5x11, 128p, 200 color images, index, order no. 1915.*

Corrective Lighting, Posing & Retouching

FOR DIGITAL PORTRAIT PHOTOGRAPHERS, 3RD ED.

Jeff Smith

Address your subject's perceived physical flaws in the camera room and in postproduction to boost client confidence and sales. *$34.95 list, 8.5x11, 128p, 180 color images, index, order no. 1916.*

THE DIGITAL PHOTOGRAPHER'S GUIDE TO

Light Modifiers

SCULPTING WITH LIGHT™

Allison Earnest

Choose and use an array of light modifiers to enhance your studio and location images. *$34.95 list, 8.5x11, 128p, 190 color images, 30 diagrams, index, order no. 1921.*

JOE FARACE'S

Glamour Photography

Farace shows you budget-friendly options for connecting with models, building portfolios, selecting locations and backdrops, and more. *$34.95 list, 8.5x11, 128p, 180 color images, 20 diagrams, index, order no. 1922.*

MORE PHOTO BOOKS ARE AVAILABLE

Amherst Media®
PO BOX 586
BUFFALO, NY 14226 USA

Individuals: If possible, purchase books from an Amherst Media retailer. Contact us for the dealer nearest you, or visit our web site and use our dealer locater. To order direct, visit our web site, or send a check/money order with a note listing the books you want and your shipping address. All major credit cards are also accepted. For domestic and international shipping rates, please visit our web site or contact us at the numbers listed below. New York state residents add 8.75% sales tax.

Dealers, distributors & colleges: Write, call, or fax to place orders. For price information, contact Amherst Media or an Amherst Media sales representative. Net 30 days.

(800) 622-3278 or (716) 874-4450
Fax: (716) 874-4508

All prices, publication dates, and specifications are subject to change without notice. Prices are in U.S. dollars. Payment in U.S. funds only.

WWW.AMHERSTMEDIA.COM
FOR A COMPLETE CATALOG OF BOOKS AND ADDITIONAL INFORMATION